# The Artist's Painting Library

# COLOR IN OIL

## BY WENDON BLAKE / PAINTINGS BY FERDINAND PETRIE

WATSON-GUPTILL PUBLICATIONS/NEW YORK

Copyright © 1982 by Billboard Ltd.

Published 1982 in the United States by Watson-Guptill Publications,
a division of Billboard Publications, Inc.,
1515 Broadway, New York, N.Y. 10036

**Library of Congress Cataloging in Publication Data**

Blake, Wendon.
    Color in oil.

    (The artist's painting library)
    Originally published as pt. 1 of: The color book.
1981.
    1. Color in art. 2. Color guides. 3. Painting—Technique. I. Petrie, Ferdinand, 1925–.
II. Title. III. Series: Blake, Wendon. Artist's
painting library.
ND1488.B56      1982      752      81-21822
ISBN 0-8230-0739-1                  AACR2

Manufactured in U.S.A.

    2 3 4 5 6 7 8 9/87 86 85 84 83

# CONTENTS

**Color in Oil Painting.** In the 500 years since oil paint was developed in fifteenth-century Flanders, artists have discovered a fascinating variety of ways to render the colors of nature in this versatile medium. Each method of applying oil paint to canvas produces its own unique kind of color effect. The range of possibilities is so rich and diverse that few artists have attempted to try them all—and most contemporary artists limit themselves to a narrow range of techniques. This book attempts to open your eyes to a variety of oil painting techniques. You'll start with the simplest and most direct techniques used by contemporary painters, and then move on to a variety of innovative techniques that may seem new to you, though many were developed centuries ago.

**Values.** Before you begin to experiment with the varied and often surprising oil painting techniques in this book, it's important to know the basics. Thus, *Color in Oil Painting* will serve both as an introduction to color for the beginning oil painter and as a review of color fundamentals for the more experienced reader. The first subject reviewed is values. Since you must know how to judge values—the comparative lightness or darkness of the colors of nature—you'll first find a brief analysis of this important subject. Then you'll learn how to paint your own value scale in oil colors—by making a chart that you can post on your studio wall as a permanent reference to help you identify values. You'll also learn how to simplify the values of nature by planning a picture in which there are just three or four basic values—and you'll watch noted artist Ferdinand Petrie paint a picture step-by-step, first in three values, then in four values.

**Color Control.** After learning about values, you'll explore what the oil colors on your palette can do. After reviewing a series of guidelines on how to mix oil colors, you'll learn how to conduct a series of tests to determine how your tube colors behave in mixtures. The result of your tests will be a series of color charts. These will serve as a permanent color reference, to be tacked on your studio wall beside your value scale. *Color in Oil Painting* also contains a series of color illustrations that will show you how to place colors side-by-side in an oil painting to increase or reduce their brightness, to make them look darker or lighter, and to create the illusion of three-dimensional space. Another series of illustrations will show you four different ways to achieve color harmony. You'll also see how to paint the varied colors of early morning, midday, late afternoon, and night in oil. And you'll find that the colors of an oil painting can be planned to reinforce your composition.

**Step-by-Step Demonstrations.** The heart of *Color in Oil Painting*, of course, is the series of ten step-by-step demonstrations in which Ferdinand Petrie shows you the varied ways oil paint can be applied to a canvas or a panel—with brush or knife—to achieve the richest possible variety of color effects. To teach you more about values, he begins by painting a picture entirely with two muted oil colors, plus white. Then he shows you how to paint a picture with just the three primary colors—red, yellow, and blue, plus white—to help you discover the surprising diversity of color mixtures you can produce with just three colors. Then he goes on to show how you can use a full palette of oil colors to produce a subdued picture, and use the same full palette to create a brighter picture. You'll then find a fascinating series of demonstrations of Old-Master techniques of underpainting and overpainting in oil: a monochrome underpainting followed by a colorful overpainting; an underpainting in a limited color range followed by an overpainting in a full range of color; a full-color underpainting followed by a full-color overpainting; and a roughly textured underpainting followed by a colorful overpainting that makes expressive use of the underlying texture. A demonstration of the wet-into-wet technique shows how to mix oil colors directly on the painting surface. And a final demonstration shows how to achieve textural richness and brilliant color by painting a picture entirely with a knife.

**Light and Shade.** Color doesn't exist without light, of course, so *Color in Oil Painting* concludes with a section on light and shade. You'll see how to use oil paint to render the pattern of light and shade on the geometric forms that underlie the shapes of nature—cubical, rounded, and conical—as well as irregular forms. There's also guidance about how to paint different kinds of lighting that are common in nature: side, three-quarter, front, back, top, and diffused lighting. A series of pictures shows you how oil paint can capture the varied light effects of different types of weather. And a concluding series of step-by-step demonstrations explains how to analyze the tonal range of your subject—the factors called *key* and *contrast*.

**A New Look at Oil Painting.** As you can see, *Color in Oil Painting* actually deals with a lot more than the usual problems of color mixing and color harmony. Its real purpose is to encourage you to take a fresh look at this marvelous medium and its amazing diversity of color effects.

**Buying Brushes.** There are three rules for buying brushes. First, buy the best you can afford—even if you can afford only a few. Second, buy big brushes, not little ones; big brushes encourage you to work in bold strokes. Third, buy brushes in pairs, roughly the same size. This is how these pairs of brushes would work: if you're painting a sky, for example, you'll probably want one brush for the blue areas and for the gray shadows on the clouds, and another brush to paint the pure white areas of the clouds.

**Brushes for Oil Painting.** Begin with a couple of really big bristle brushes, around 1″ (25 mm) wide for painting your largest color areas. You might want to try different shapes: one can be a flat, while the other might be a filbert, and one might be just a bit smaller than the other. The numbering systems of manufacturers vary, but you'll probably come reasonably close if you buy a number 11 and a number 12. You'll also need two or three bristle brushes about half this size, numbers 7 and 8 in the catalogs of most brush manufacturers. Again, try a flat, a filbert, and perhaps a bright. Then, for painting smoother passages, details, and lines, you'll find three soft-hair brushes useful: one that's about ½″ (13 mm) wide; one that's about half this wide; and a pointed, round brush that's about ⅛″ or ³⁄₁₆″ (3 to 5 mm) thick at the widest point.

**Knives.** For scraping a wet canvas when you want to correct or to repaint something, a palette knife is essential. Many oil painters also prefer to mix colors with a knife (rather than a paintbrush). If you like to *paint* with a knife, however, don't use a palette knife. Instead, buy a painting knife with a short, flexible, diamond-shaped blade.

**Painting Surfaces.** When you're starting to paint in oil, you can buy inexpensive canvas boards at any art supply store. Canvas boards are made of canvas that has been coated with white paint and glued to sturdy cardboard. They come in standard sizes that will fit into your paintbox. Later, you can buy stretched canvas: sheets of canvas precoated with white paint, nailed to a rectangular frame made of wooden "stretcher bars." If you like to paint on a smooth surface, buy sheets of hardboard and coat them with acrylic gesso, a thick, white paint that you buy in cans or jars.

**Easel.** An easel is helpful, but not essential. Basically, an easel is just a wooden framework with two "grippers" that hold the canvas upright while you paint. The "grippers" slide up and down to fit larger or smaller paintings—and to match your height. If you'd rather not invest in an easel, you can always hammer a few nails partway into the wall and rest your painting on them. If the heads of the nails overlap the painting, they'll hold it securely. You can also use your paintbox lid as an easel.

**Paintbox.** To store your painting equipment and to carry your gear outdoors, a wooden (or aluminum) paintbox is a great convenience. The box has compartments for brushes, knives, tubes, small bottles of oil and turpentine, and other accessories. It usually holds a palette—plus some canvas boards—inside the lid.

**Palette.** A wooden paintbox often comes with a wooden palette. Before you squeeze out your paint on it, rub the palette with several coats of linseed oil to make the surface smooth, shiny, and nonabsorbent. When the oil is dry, the palette won't soak up your tube colors, and the surface will be easy to clean at the end of the painting day. A paper palette is even more convenient. This looks like a sketchpad, but the pages are nonabsorbent paper that comes in standard sizes that fit into paintboxes. At the beginning of the painting day, you squeeze out your colors on the top sheet. When you've finished painting, you just tear off and discard the sheet.

**Odds and Ends.** To hold your turpentine and your painting medium—which might be plain linseed oil or one of the mixtures you'll read about shortly—you should buy a pair of metal palette cups (or "dippers") to clip onto your palette. You'll also need a few sticks of natural charcoal—not charcoal pencils or compressed charcoal—to sketch the composition on your canvas before you start to paint. Then you'll need to keep a clean rag or paper towel handy to dust off the charcoal and make the lines paler before you start to paint. Smooth, absorbent, lint-free rags are also good for wiping mistakes off your painting surface. Paper towels or a stack of old newspapers (which is a lot cheaper) is essential for wiping your brush after you've rinsed it in solvent.

**Work Layout.** Before you start to paint, lay out your equipment in a consistent way so that everything is always in its place when you reach for it. If you're righthanded, place the palette on a table to your right, along with a jar of solvent, your rags and newspapers, your paper towels, and a clean jar in which you store your brushes (hair end up). Also, establish a fixed location for each color on your palette. One good arrangement is to place your *cool* colors (black, blue, green) along one edge, and the *warm* colors (yellow, orange, red, brown) along another edge. Put a big dab of white in a corner where it won't be fouled by other colors.

**Color Selection.** When you walk into an art supply store, you'll probably be dazzled by the number of different colors you can buy. But there are far more tube colors in existence than any artist can use. In reality, all the oil paintings in this book are done with roughly a dozen colors, about the average number used by most professionals. So the colors listed below can be enough for a lifetime of painting. You'll notice that most colors are in pairs—two blues, two reds, two yellows, two browns—and that one member of each pair is bright while the other is more subdued. This combination should give you the greatest possible range of color mixtures. Now here's a suggested palette.

**Blues.** Ultramarine blue is a dark, subdued hue with a faint hint of violet. Phthalocyanine blue is much more brilliant and has surprising tinting strength. Since this means that just a little goes a long way when you mix it with another color, you must always add phthalocyanine blue very gradually to your mixtures. Although these two blues will do almost every job, you may want to keep a tube of cerulean blue handy for painting skies, distant hills, and other atmospheric tones. This beautiful, delicate blue can be considered an optional color.

**Reds.** Cadmium red light is a fiery red with a hint of orange. (All cadmium colors have tremendous tinting strength, so remember to add them to mixtures just a bit at a time.) Alizarin crimson is a darker red and has a slightly violet cast.

**Yellows.** Cadmium yellow light is a dazzling, sunny yellow with tremendous tinting strength, like all the cadmiums. Yellow ochre is a soft, tannish tone. If your art supply store carries two shades of yellow ochre, buy the lighter one.

**Browns.** Burnt umber is a dark, somber brown. Burnt sienna is a coppery brown that has a suggestion of orange.

**Green and Orange.** Although nature is full of greens—and so is your art supply store—you can mix an extraordinary variety of greens with the colors on your palette. But it *is* convenient to have just one green available in a tube. The most useful green is a bright, clear hue called viridian. The reds and yellows on your palette will make a variety of oranges, but you still may enjoy having the brilliant, sunny cadmium orange on your palette. Both viridian and cadmium orange are optional colors.

**Black and White.** The standard black used by almost every oil painter is ivory black. The white you buy can be either zinc white or titanium white. Al-ways buy the biggest tube of white you can find because you'll be using lots of it.

**Linseed Oil.** Although the color in the paint tubes already contains linseed oil, the manufacturer adds only enough oil to produce a paste thick enough to squeeze out in little mounds around the edge of your palette. To make the paint more fluid, you can add more linseed oil to the color on your palette. So pour some oil into one of the metal cups (or "dippers"). You can then dip your brush into the oil, pick up some paint on the tip of the brush, and blend oil and paint together on your palette to produce the consistency you want.

**Solvent.** You'll also need a big bottle of turpentine or one of the petroleum solvents—called mineral spirits, white spirit, or rectified petroleum—to fill the second metal cup you have clipped to the edge of your palette. You can then add a few drops of solvent to the mixture of paint and linseed oil on your palette. The more solvent you add, the thinner the paint will become. (Some oil painters prefer to pre-mix their linseed oil and solvent, 50–50, in a bottle before they start. They then keep this thin "painting medium" in one palette cup and pure solvent—for thinning it further—in the other.) For cleaning your brushes as you paint, you can pour some solvent into a small jar and keep it handy. Then, when you want to rinse out the color on your brush before picking up fresh color, you simply swirl the brush around in the solvent and wipe the bristles on a newspaper.

**Painting Mediums.** The simplest painting medium is the traditional 50–50 blend of linseed oil and solvent. Many painters are satisfied to thin their paint with that medium for the rest of their lives. However, after you've tried the traditional medium, you might like to try some commercial mediums, available in art supply stores. The most popular ones are usually a blend of resin, solvent, and perhaps some linseed oil and are called damar, copal, mastic, or alkyd mediums. The resin that's added is really a kind of varnish that adds luminosity to the paint and makes it dry more quickly.

**Varnishes.** A finished oil painting is normally protected by a layer of varnish. There are two types, retouch varnish and picture varnish. As soon as the painting surface feels dry to your fingertips, you can brush or spray on a coat of *retouch varnish* to make the surface appear glossy. After your painting has been dry for about six months, most oil paintings are ready for a coat of *picture varnish*. So buy a bottle of both retouch and picture varnish.

**Talking About Color.** When artists discuss color, they use a number of words that may or may not be familiar to you. Because many of these words will appear in this book, this page will serve as a kind of informal glossary of color terms.

**Hue.** When you talk about color, the first thing you'll probably do is talk about its hue. That is, you'll name the color. You'll say that it's red or blue or green. That name is the *hue*.

**Value.** As you begin to describe that color in more detail, you'll probably say that it's dark or light or something in between. Artists use the word *value* to describe the comparative lightness or darkness of a color. In judging value, it's helpful to pretend that you're temporarily colorblind, so that you see all colors as varying tones of black, gray, and white. Thus, yellow becomes a very pale gray—a light or high value. In the same way, a deep blue is likely to be a dark gray or perhaps black—a low or dark value. And orange is probably a medium gray—a middle value.

**Intensity.** In describing a color, artists also talk about its comparative intensity or brightness. The opposite of an intense or bright color is a subdued or muted color. Intensity is hard to visualize, so here's an idea that may help: pretend that a gob of tube color is a colored light bulb. When you pump just a little electricity into the bulb, the color is subdued. When you turn up the power, the color is more intense. When you turn the power up and down, you don't change the hue or value—just the brightness or *intensity*.

**Temperature.** For psychological reasons that no one seems to understand, some colors look warm and others look cool. Blue and green are usually classified as cool colors, while red, orange, and yellow are considered warm colors. Many colors can go either way. A bluish green seems cooler than a yellowish green, while a reddish purple seems warmer than a bluish purple. And there are even more subtle differences: a red that has a hint of purple generally seems cooler than a red that has a hint of orange; a blue with a hint of purple seems warmer than a blue that contains a hint of green. All these subtle differences come under the heading of *color temperature*.

**Putting It All Together.** When you describe a color, you generally mention all four of these factors: hue, value, intensity, and temperature. If you want to be very technical, you might describe a particular yellowish green as "a high-value, high-inten-sity, warm green." Or you might say it more simply: "a light, bright, warm green."

**Primary, Secondary, and Tertiary Colors.** The primaries are blue, red, and yellow—the three colors you can't produce by mixing other colors. To create a secondary, you mix two primaries: blue and red to make violet; blue and yellow to make green; red and yellow to make orange. The six tertiary colors are blue-green, yellow-green, blue-violet, red-vio-let, red-orange, and yellow-orange. As you can guess, the tertiaries are created by mixing a primary and a secondary: red and orange produce red-orange, yellow and orange produce yellow-orange, etc. You can also create tertiaries by mixing uneven amounts of two primaries: a lot of red and a little yellow will make red-orange; a lot of blue and a little yellow will make blue-green, and so forth.

**Complementary Colors.** The colors that are opposite one another on the color wheel are called *complementary colors* or just *complements*. As you move your eye around the color wheel, you'll see that blue and orange are complements, blue-violet and yellow-orange are complements, violet and yellow are complements, and so forth. Memorize these pairs of complementary colors, since this information is useful in color mixing and in planning the color scheme of a painting. One of the best ways to subdue a color on the palette—to reduce its intensity—is to add a touch of its complement. On the other hand, one of the best ways to brighten a color in your painting is to place it next to its complement. Placing complements side by side is also one of the best ways to direct the viewer's attention to the center of interest in a painting, since this always produces a particularly vivid contrast.

**Analogous Colors.** When colors appear next to one another—or fairly close—on the color wheel they're called *analogous* colors. They're considered analogous because they have something in common. For example, blue, blue-green, green, and yellow-green are analogous because they *all* contain blue. Planning a picture in analogous colors is a simple, effective way to achieve color harmony.

**Neutral Colors.** Brown and gray are considered neutral colors. A tremendous variety of grays and browns—which can be quite colorful in a subtle way—can be mixed by combining the three primaries or any pair of complements in varying proportions. For example, various combinations of reds and greens make a diverse range of browns and grays, depending upon the proportion of red and green in the mixture.

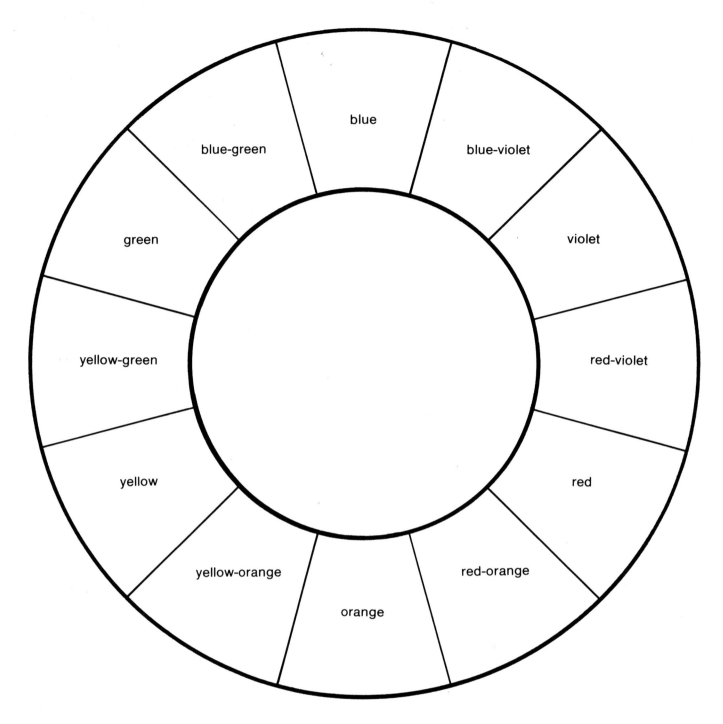

**Classifying Colors.** It's helpful to memorize the classic diagram that artists call a *color wheel*. This simple diagram contains the solutions to a surprising number of color problems you may run into when you're working on a painting. For example, if you want a color to look *brighter*, you'd place a bit of that color's complement nearby to strengthen it. You'll find the complement directly across the wheel from the other color. On the other hand, if you want to *subdue* that original color, you'd blend a touch of its complement into the original color. If color harmony is your problem, one of the simplest ways to design a harmonious color scheme is to choose three or four colors that appear side-by-side on the color wheel, and build your painting around these *analogous* colors. Then, to add a bold note of contrast, you can enliven your color scheme by introducing one or two of the complementary colors that appear on the opposite side of the wheel from the original colors that you've chosen for your painting.

**Plan Your Mixtures.** Certainly the most important "rule" of color mixing is to plan each mixture before you dip your brush into the wet colors on your palette. Don't poke your brush into various colors and scrub them together at random, adding a bit of this and a bit of that until you get what you want—more or less. Instead, at the very beginning, you must decide which colors will produce the mixture you want. Try to limit the mixture to just two or three tube colors plus white—or water if you're working with watercolor—to preserve the brilliance and clarity of the mixture.

**Don't Overmix.** No one seems to know why, but if you stir them around too long on the palette, colors *lose* their brilliance and clarity. So don't mix your colors too thoroughly. As soon as the mixture looks right, stop.

**Work with Clean Tools.** To keep each mixture as pure as possible, be sure your brushes and knives are clean before you start mixing. If you're working with oil paint, rinse the brush in solvent and wipe it on a scrap of newspaper before you pick up fresh color or, better still, try mixing with a palette knife, wiping the blade clean before you pick up each new color. If you're working with watercolor or acrylic, rinse the brush in clean water, making sure to replace the water in the jar as soon as it becomes dirty.

**Getting to Know Your Medium.** As you experiment with different media, you'll discover that subtle changes take place as the color dries. When you work in oil, you'll discover that it looks shiny and luminous when it's wet, but often "sinks in" and looks duller after a month or two, when the picture is thoroughly dry. Some painters restore the freshness of a dried oil painting by brushing or spraying it with retouching varnish. A better way is to use a resinous medium—damar, mastic, copal, or alkyd—when you paint. A resinous medium preserves luminosity because it's like adding varnish to the tube color. If you're working in watercolor, you'll find that watercolor becomes paler as it dries. To make your colors accurate, you'll have to make all your mixtures darker than you want them to be in the final picture. And if you're using acrylic, you'll discover that, unlike watercolor, acrylic has a tendency to become slightly more subdued when it dries. So you may want to exaggerate the brightness of your acrylic colors as you mix them.

**Lightening Colors.** The usual way to lighten oil color is to add white, while the usual way to lighten watercolor is simply to add water. If you're working with acrylic, you can do both: you can add white to lighten an opaque mixture and water to lighten a transparent one. However, it's not always that simple. White may not only lighten the color; it may actually change it. For example, a hot color like cadmium red light rapidly loses its intensity as it gets paler, so it may be a good idea to restore its vitality by adding a touch of a vivid color (like alizarin crimson) in addition to white or water. If the crimson turns your mixture just a bit too cool, you may also want to add a speck of cadmium yellow. In other words, as you lighten a color, watch carefully and see if it needs a boost from some other hue.

**Darkening Colors.** The worst way to darken any color is by adding black, because it tends to destroy the vitality of the original hue. Instead, try to find some other color that will do the job. For example, try darkening a hot red or orange—such as cadmium red light, alizarin crimson, or cadmium orange—with a touch of burnt umber or burnt sienna. Or darken a brilliant hue like cadmium yellow light by adding a more subdued yellow like yellow ochre. Although darkening one rich color with another may produce slight changes in hue or intensity, this is preferable to adding black.

**Brightening Colors.** Experimentation is the only way to find out how to brighten each color on your palette, since every color behaves in its own unique way. For example, a touch of white (or water) will make cadmium yellow light look brighter, while that same touch of white will make cadmium orange look more subdued. As it comes from the tube, cadmium red light looks so brilliant that it's hard to imagine any way to make it look brighter, but a touch of alizarin crimson will do it. Ultramarine blue looks dull and blackish as it comes from the tube, yet a touch of white (or water) will bring out the richness of the blue. It will become even brighter if you add a tiny hint of green.

**Subduing Colors.** Again, the first rule is to avoid black, which *will* subdue your color by reducing it to mud. Instead, look for a related color, one that's less intense than the color you want to subdue. The color tests described in the oil, watercolor, and acrylic parts of this book will show you how each color behaves when it's mixed with every other color on your palette. The texts should also help you decide which color to choose when you want to lessen another color's intensity. For example, a touch of yellow ochre is often a good way to reduce the intensity of the hot reds, oranges, and yellows. And a speck of burnt umber will reduce the intensity of blue without a major color change.

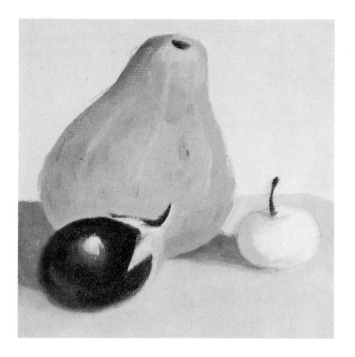

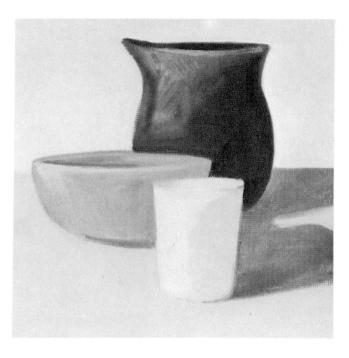

**Vegetables and Fruit.** To learn about values—the comparative lightness and darkness of colors—paint a series of little pictures entirely with mixtures of black and white. When you convert the colors of this still life into values, the dark purple eggplant is almost black, the yellow-orange squash is gray, and the pale yellow apple is almost white.

**Kitchen Containers.** Study your subject and mix each value on the palette before you start to paint. After you've applied these mixtures to the canvas, you can make adjustments by blending a lighter or darker tone into the wet color. In this kitchen still life, the brown pitcher becomes a deep gray, the light green bowl becomes a soft gray, and the pale blue glass is almost white.

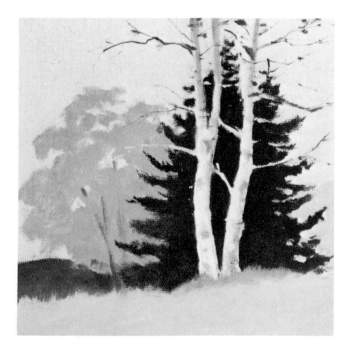

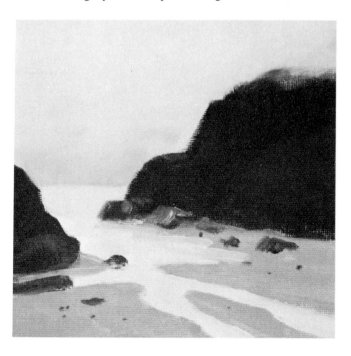

**Trees.** In translating this landscape into values, the pale birches appear almost white against the dark gray that represents the deep blue-green evergreens. The soft green distant trees become a pale gray, the sunlit yellow-green grass in the foreground is represented by a value similar to that of the pale birches, and the deeper green of the shadowy grass becomes a dark gray.

**Beach.** In this coastal landscape, the pale blue sky becomes a delicate gray (almost white)—a value that's also mirrored in the tide pools. The dark brown rock formations convert to a dark gray and the tan patches of sand between the pools become a medium gray. Paint your value studies on small canvas boards with broad, simple strokes. Don't worry about detail.

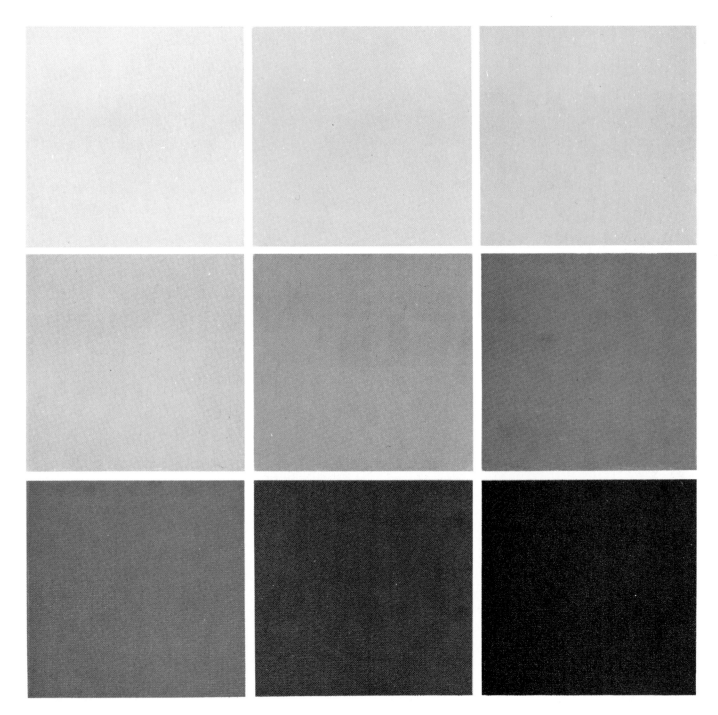

**Classifying Values.** The job of converting color into value becomes a lot easier if you take the time to paint a value scale and tack it on your studio wall. You'll find it convenient to refer to the value scale as you paint. Eventually, you'll memorize it without even trying. At that point, you can drop the scale into a drawer and consult the "chart" in your head. Theoretically, the values of nature are as infinite as the colors. But this scale simplifies the number of possibilities to just ten values—all you really need. Squeeze out plenty of black and white on your palette, and then carefully paint a series of nine squares on a canvas board, starting with the palest gray at the upper left, gradually making each square a bit darker, and finishing with a black square at the lower right. The tenth value—pure white—is the tone of the bare canvas. It takes time and patience to paint (and often repaint) these squares to get the sequence of the values exactly right. But once the chart is finished, you'll be able to look at the pale yellow of a lemon and find its value at the upper end of the scale, or study the deep purple of a plum and find its value at the lower end of the scale. If you find it helpful, you can assign numbers or letters of the alphabet to the ten values on the scale.

# PAINTING IN THREE VALUES

**Step 1.** Professional painters know they can't match the infinite values of nature, so they simplify them to create a strong pictorial design. Many painters find that they can create a satisfying picture with just three dominant values: a *dark*, a *light*, and a *middletone* that falls somewhere between the other two. In this three-value still life, the artist draws the pitcher, bowl, fruit, and vegetables with pure black to indicate their shapes and placement. Adding a touch of white to the black, he blocks in the darkest tone in the picture—on the bowl, on the carrot tops at the right, and in the shadows that are cast by the pitcher, the bowl, and the other objects.

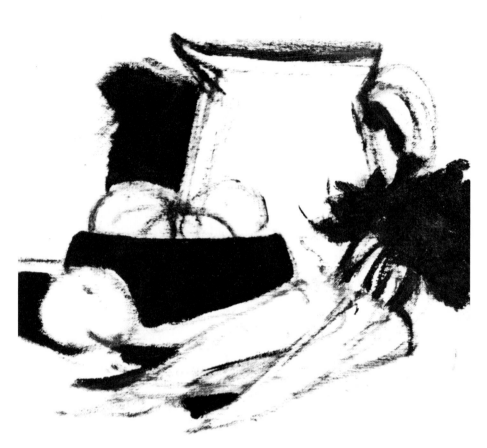

**Step 2.** Studying his subject closely, the artist decides that the middletone appears on the pitcher, the tablecloth, and the shadow sides of the fruit and vegetables. Blending a bit of black into a lot of white, he covers the middletone areas of the canvas with broad, flat strokes. The light tone of the wall behind the pitcher and the lighted areas of the fruit and vegetables are all represented by bare canvas. Even at this early stage, the three values are already obvious. With the minimum number of strokes, the artist has now given us a clear idea of the forms and the distribution of light and shade. The picture has already become a satisfying pictorial design.

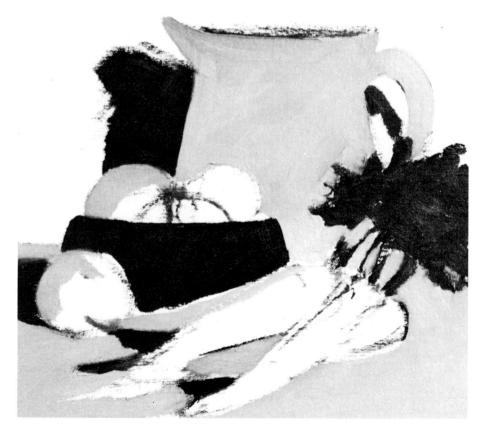

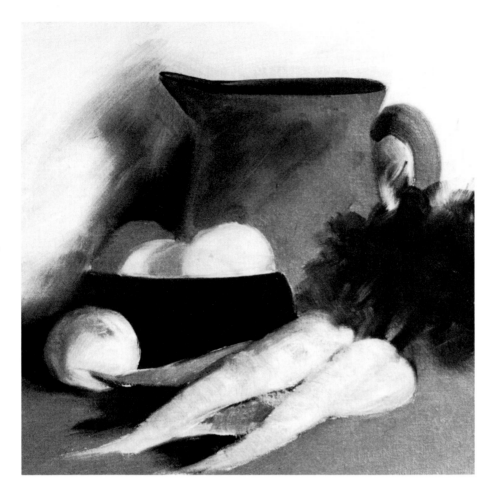

**Step 3.** The artist covers the patches of bare canvas with a delicate gray—white mixed with a speck of black. Now the entire canvas is covered with wet color that the artist can modify by blending in additional touches of tone. He decides that the shadows at the left of the pitcher and bowl actually contain two values: the dark and the middletone. He blends the middletone into the dark edge of the shadow. He also decides that the opening in the pitcher is the same dark that's in the shadows. A few dark touches make the pitcher look rounder. He adds lighter touches to the carrot tops and to the shadows cast by the carrot. He blends the lights and middletones of the fruit and vegetables so they flow softly together, although the original values are still obvious.

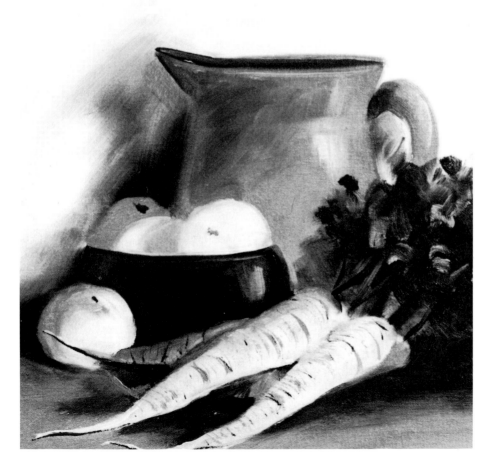

**Step 4.** The artist makes the carrot tops more realistic by working some middletone strokes into the darks at the extreme right. He also extends the dark value downward to create a shadow beneath the carrot tops and the carrots in the lower right. A few strokes of the light value suggest highlights on the pitcher and bowl. A small, round brush picks up the middletone to render the rounded shape and texture of the carrots. He adds dark stems to the carrot tops and fruit. Virtually the entire job has been done with three values. But why paint "practice pictures" in black and white when your goal is to paint in color? When you start to mix colors, your experience with values will make it a lot easier to decide how dark or light these mixtures should be.

**Step 1.** When three values aren't quite enough, four values—light, dark, and two middletones—will often do the job. (Many landscape painters consistently work with four values.) In this study of trees and rocks by the side of a lake, the artist makes a rough drawing of the shapes with black and a lot of turpentine. Selecting his dark from the lower part of the value scale, he blocks in the shape of the evergreen and its shadow on the ground with black that's modified with a touch of white. At this stage, he concentrates entirely on the shape of the silhouette, merely suggesting a few details within the foliage. The actual evergreen is a deep blue-green that becomes a blackish gray when the artist converts color to value.

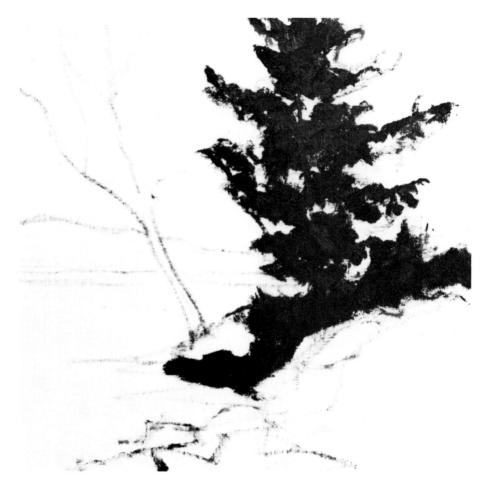

**Step 2.** Studying the lightest color in the landscape—the pale blue of the sky, which reappears in the water—the artist chooses a light gray from the upper part of the value scale. He mixes this tone with lots of white and a touch of black. Examining the soft green foliage on the distant shore, the light brown rocks along the foreground shoreline, and the sunlit grass to the left of the tree, he decides that all three are the same middletone. So he mixes a medium gray (from the central area of the value scale) and covers these three areas with broad, flat strokes. There are still three patches of bare canvas: the leafless tree leaning over the water; the ground in the lower right corner; and the pale strip beneath the distant shore.

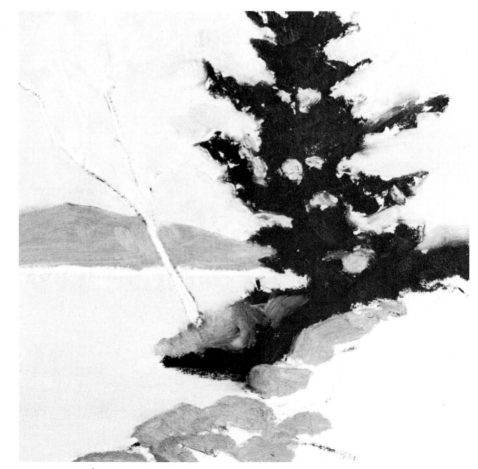

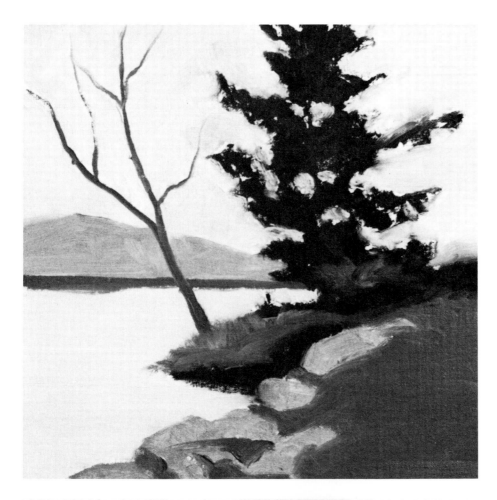

**Step 3.** For the dark green grass in the lower right corner, the brown, leafless tree and branches, and the dark strip of shadow beneath the far shore, the artist mixes a second, *darker* middletone. He decides that the patch of grass right under the trees is darker than he thought, so he repaints it the same middletone as the rest of the grass. Now the value scheme of the whole painting is clear. The darkest value is on the big evergreen, the shadow beneath it, and on the shadowy edge of the shore just beyond the rocks. The darker middletone is on the grass, the leaning tree, and the shadowy strip under the far shore. The lightest value is in the sky and on the water that reflects the sky like a mirror. At this stage, the painting looks like a poster, with flat, simple shapes.

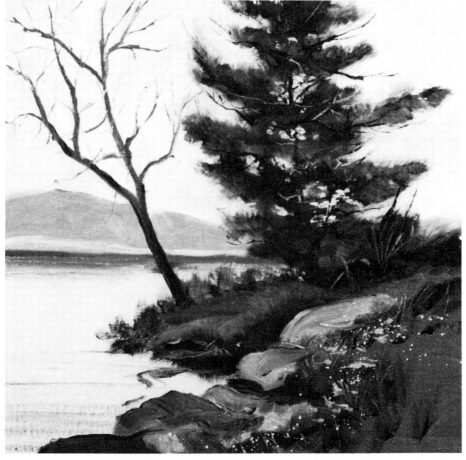

**Step 4.** The artist begins to make adjustments in the wet paint. He blends strokes of the darker middletone into the evergreen; adds darks for the shadows on the foreground rocks and on the trunk and branches of the leafless tree; and uses the pale value of the sky to suggest light-struck branches against the dark evergreen, and weeds and wildflowers in the foreground. The rough grass beneath the leaning tree is scrubbed in with the darker middletone, which is also used for the wiggly stroke that represents the trunk's reflection in the water. Beneath the far shore, a strip of sky value suggests light on the water. Throughout the picture, the artist gently blends the edges where the values meet. The values are no longer so obvious, but they're still there.

**Getting to Know Oil Colors.** To work with oil colors successfully, you must learn how every color on your palette behaves when it's mixed with every other color. No two colors behave exactly alike, and their behavior can be unpredictable. For example, you've certainly been taught that you can make purple by combining red and blue. That *is* true when you mix phthalocyanine blue with alizarin crimson, but prepare yourself for a shock when you mix phthalocyanine blue with cadmium red. The result is a strange brown that has its own special kind of beauty, but it's certainly not purple! Rather than make surprising discoveries like this one in the middle of a painting, it's best to store up this information by conducting a series of tests and recording the results on color charts. These charts are fun to make and useful to tack on your studio wall.

**Making Color Charts.** Buy a pad of inexpensive, canvas-textured paper, or collect some old scraps of canvas and cut them to a size that's roughly that of the page you're now reading. With a sharp pencil, or perhaps a felt or fiber-tipped marker, plus a ruler, draw a series of boxes on the paper or canvas, forming a kind of checkerboard. The boxes should be 2″ to 3″ (50 to 76 mm) square. Each box should give you just enough space for a single color mixture. (Don't forget to write the names of the colors in the boxes.) The simplest way to plan these color charts is to make a separate chart for each color on your palette. If you draw a dozen boxes on each chart, you'll have enough boxes to mix ultramarine blue, for example, with white and with all the other colors on your palette. If you run out of room on one chart, continue your mixtures on a second chart.

**Adding White.** Because you'll eventually be mixing white with every other color on your palette, it's essential to find out how each tube color behaves when it's blended with white. Place a few broad strokes of color in its box on the chart. Then pick up a clean brush, dip it into pure white, and scrub the white into *half* of the tube color in the box. Now you've got a color sample that's divided into two halves: one half is the pure tube color and the other half is tube color blended with white. When you study the completed charts, you'll discover some fascinating facts. For example, while a touch of white brightens the blues and makes yellows even sunnier, it reduces the intensity of reds and oranges.

**Mixing Pairs of Colors.** Here's how to mix every color on your palette with every other color. Paint a thick stroke of each color, slanting the strokes inward so they converge. At the point where they converge, scrub the colors together to find out what kind of mixture they make. It may be necessary to add a touch of white to the mixture to bring out the full color. For example, a mixture of ultramarine blue and viridian will look dark and dull, but a gorgeous blue-green emerges when you add just a little white. On the other hand, cadmium red light and cadmium yellow light will produce a stunning orange without the aid of white. Once again, prepare yourself for some surprises. Although experienced oil painters normally avoid adding black to subdue another color, ivory black produces wonderful mixtures when it's used as a cool color, like blue or green. Thus, the combination of yellow ochre and ivory black will produce a lovely, subtle olive green or greenish brown that's useful in landscape painting. And cadmium orange joins with ivory black to produce lovely coppery tones.

**Optical Mixing.** When you blend two wet colors on your palette or directly on the painting surface, this is a *physical* mixture. But there's another way to mix colors that's been neglected by contemporary painters, although it was widely used by the Old Masters. In this method, the Old Masters often placed a layer of color on the canvas, allowed that layer to dry, then brushed on a second layer of transparent color (called a *glaze*) or semi-transparent color (called a *scumble*) that allowed the underlying color to shine through. The two colors mixed in the eye of the viewer to form a third color—an *optical* mixture. Glazing and scumbling produce color effects that are impossible to get through purely physical mixtures. Several of the demonstrations in *Color in Oil Painting* involve such optical mixtures. To see how optical mixtures work, you'll probably have to start a new chart. Paint a few strokes of tube color in its own box on the color chart. (Lighten some of the darker colors such as black, blue, green, and brown with white.) Leave some canvas bare at one end of the box. Let the strokes dry. Before you brush the second color over the dry paint, add some painting medium to make the tube color fluid and transparent. Then brush this glaze over the bare canvas and then carry the color *halfway* over the dried color. Now you can see how the underlying color looks by itself, how the transparent color looks by itself on the bare canvas, and how the two colors combine optically to create a third color. It's revealing to compare a physical mixture and an optical mixture of the same two colors: the optical mixture is sometimes more subtle and mysterious, sometimes more brilliant.

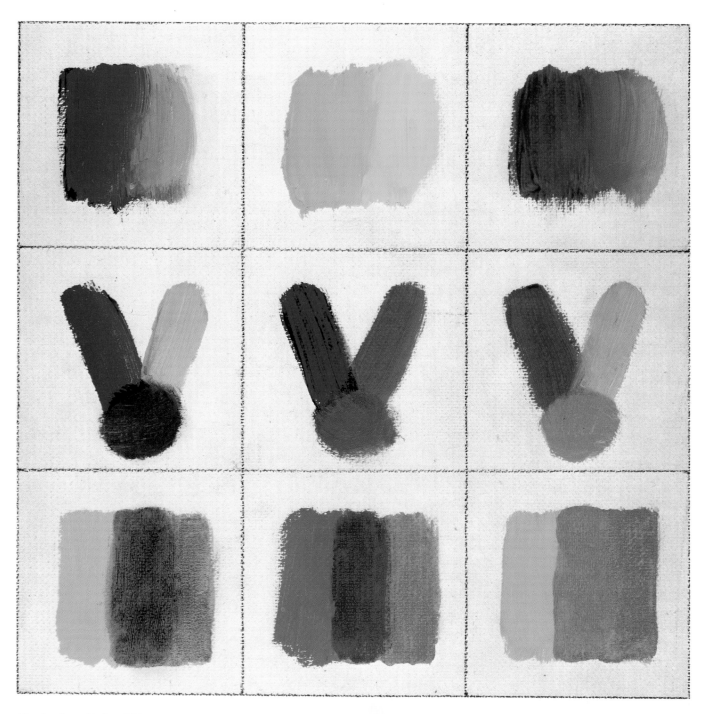

**Exploring Color Mixtures.** Here are some samples of the mixtures to test on your color charts. (Bear in mind that this isn't a typical chart but a selection of typical boxes from various charts.) In the top row, there are three primary colors, each taken straight from the tube *and* blended with white. Ultramarine blue (left) as it comes from the tube is fairly dark and subdued, but turns to a soft blue with a hint of warmth when you add white. Cadmium yellow (center) is bright and sunny from the tube, and even sunnier with white added. Alizarin crimson (right) is rather murky as it comes from the tube, but turns bright pink with a touch of white. In the second row, from left to right, a stroke of ultramarine blue and a stroke of cadmium yellow meet to form a subdued green; ultramarine blue and alizarin crimson produce a soft vio-

let; and alizarin crimson and cadmium yellow make a hot orange. These six mixtures are all *physical mixtures*; that is, two wet colors are brushed together to produce a third. The third row shows *optical mixtures* in which one color is allowed to dry, and then a second color is diluted with painting medium to a transparent consistency that's brushed halfway over the first color. From left to right, ultramarine blue is brushed over cadmium yellow, alizarin crimson over ultramarine blue (lightened with white), and alizarin crimson over cadmium yellow. In a printed book, the differences between physical and optical mixtures are less obvious than they'll be when you paint your own color charts—so be sure to try optical mixtures for yourself.

**Complementary Background.** You can also control your colors by the way you plan color relationships—by carefully selecting the colors you place next to one another. The tones of this brilliant autumn tree are mixtures of cadmium yellow light, cadmium red light, and burnt sienna. But the red-golds look particularly bright because the autumn foliage is surrounded by the complementary colors of the trees in the background, which are deep green, punctuated by touches of blue. If you look back at your color wheel, you'll see that green is the complement of red and blue is the complement of orange. These two cool colors work together to intensify the warm autumn foliage by contrast.

**Analogous Background.** But what if you *don't* want that autumn tree to look quite so bright? The solution is to surround the tree with analogous colors—colors that are *near* each other on the color wheel—instead of the complementary colors at the *opposite* side of the wheel. Here, the artist has surrounded the red-gold tree with reds and browns that harmonize with the tree instead of contrasting with it. The brilliant tree begins to melt away into the background. However, that touch of blue sky (the complement of orange) helps to emphasize the general warmth of the entire landscape.

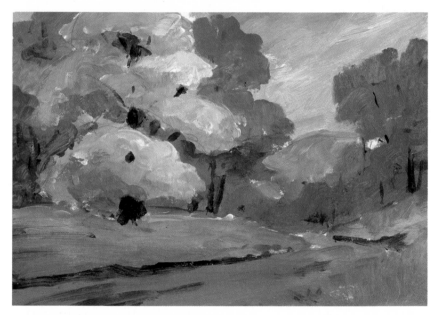

**Neutral Background.** What if you want to dramatize the brilliant color of the tree but you *don't* want to surround it with other bright colors? You can surround the bright colors with neutrals—with grays or browns or brown-grays that will stay quietly in the background. In this oil sketch, the bright autumn foliage is surrounded by subdued mixtures of ultramarine blue, burnt umber, and white. This is an overcast day, so the sky and foreground are also painted in quiet, neutral colors. The "rules" are simple: to make a color look brighter, surround it with complements or neutrals; to make a color look more subdued, surround it with analogous colors.

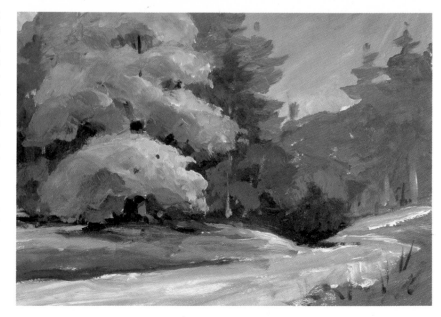

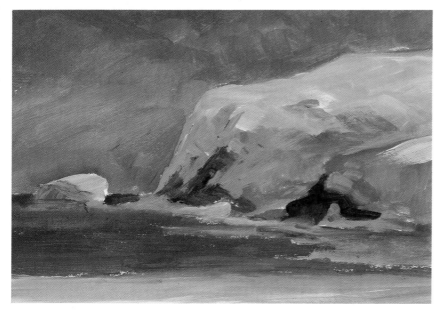

**Dark Background.** Just as the background colors can affect the intensity of a color, they can also affect its value. The sunlit top of this cliff—a mixture of cadmium yellow light, burnt sienna, viridian, and white—looks lightest and sunniest against a dark sky. The dark tone of the sky is reflected in the water, which also surrounds the cliff, giving further emphasis to the bright top of the small rock at the extreme left. The cool, dark tones are mixtures of ultramarine blue, burnt sienna, yellow ochre, and white.

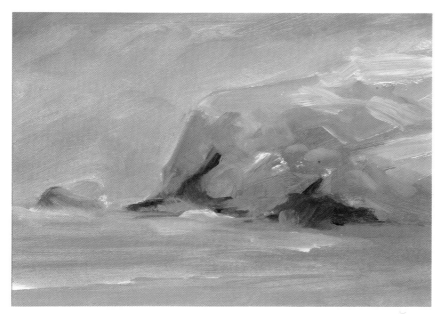

**Middletone Background.** Of course, there's no law that says you've got to emphasize the sunny top of the cliff and rock. You may prefer to let the cliff and rock stay quietly in the distance. For this purpose, a good strategy is to surround the cliff with a middletone that's not much darker or lighter than the value of the cliff itself. In this second oil sketch of the same subject, the sky is a paler mixture of ultramarine blue, viridian, burnt sienna, and more white, with the same mixture repeated in the water. There's less contrast between the values of the cliff, rock, sky, and water. The sunny tops of the cliff and rock are de-emphasized.

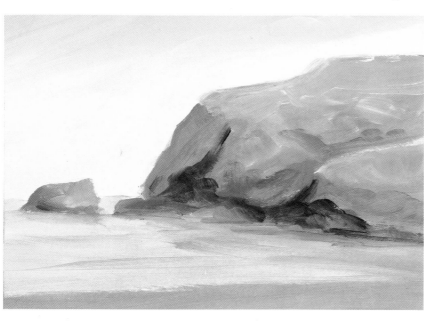

**Light Background.** Rather than emphasize the sunlit cliff against the dark sky, you may want to dramatize the *dark* silhouettes of the rocky shapes. In this case, your strategy might be to place the cliff against a pale sky. Now the value of the sky and water is much lighter, while the big cliff and the small rock look darker. Sky and water are both mixtures of ultramarine blue, viridian, yellow ochre, and lots of white. Once again, the "rules" are simple: to make a shape look lighter, place it against a dark background; to make it look darker, choose a light background; to de-emphasize the shape, choose a background that's roughly the same value.

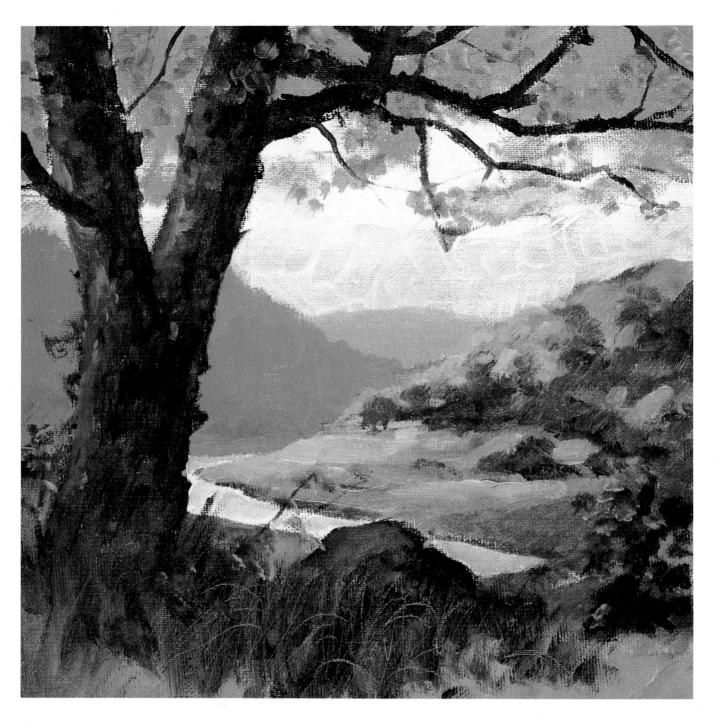

**Sunny Day.** To create a convincing sense of space in a painting—particularly in a landscape or a seascape—it's important to understand the "laws" of *aerial perspective.* According to these "laws," the colors closest to the viewer tend to be darker, warmer, and brighter than the colors in the distance, but as objects recede into the distance, their colors tend to grow cooler, paler, and less intense. In fact, that's what's happening in this landscape. The darkest colors are in the shadowy foreground, and the brightest colors are on the sunlit slope just beyond. As your eye moves to the slope in the middleground, just beyond the dark tree on the left, you see that the hill is paler and cooler. And the very distant mountain in the middle of the picture, just beneath the sky, is paler and cooler still. Warm colors dominate the mixtures in the foreground: burnt sienna, yellow ochre, and ivory black in the trees and rocks; cadmium yellow light, burnt sienna, and ultramarine blue on the sunny slopes. Beyond the sunny slopes, cooler colors begin to take command: phthalocyanine blue, viridian, burnt umber, and white for the hill in the middleground; ultramarine blue with a touch of alizarin crimson and a lot of white in the paler mountain at the horizon.

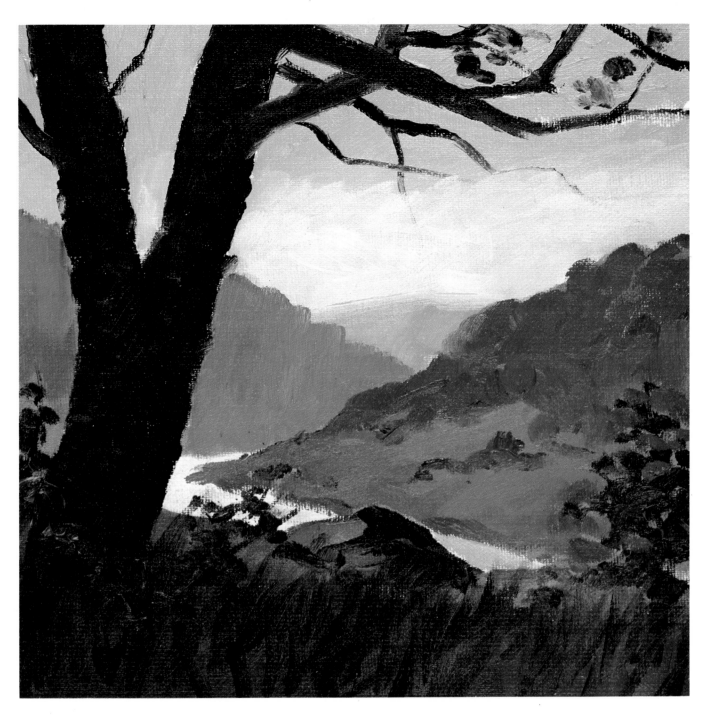

**Overcast Day.** Although the colors become a lot more subdued on an overcast day, the basic "laws" of aerial perspective still apply in any kind of weather. Typically, all the colors are cooler and more muted when the sun disappears behind a layer of clouds. But the tree, grass, and rock in the immediate foreground are still the darkest, warmest elements in this landscape; they're mixtures of burnt umber, yellow ochre, and ultramarine blue. The nearby slope is no longer sunny, but it's still brighter than the slopes in the distance; it's a mixture of phthalocyanine blue, yellow ochre, burnt sienna, and white. The hill in the middleground, just beyond the tree, becomes cooler, paler, and more subdued—painted with a mixture of ultramarine blue, burnt umber, yellow ochre, and white. And the remote mountain at the horizon is the palest mixture in the landscape: a little ultramarine blue and burnt umber, plus lots of white. Comparing these two studies of the same landscape, it's exciting to see how a change in weather can create two totally different pictures. As many great artists have done, you can set up your easel in the same place every day, discovering dramatic new possibilities in the subject as the weather and the seasons change before your eyes.

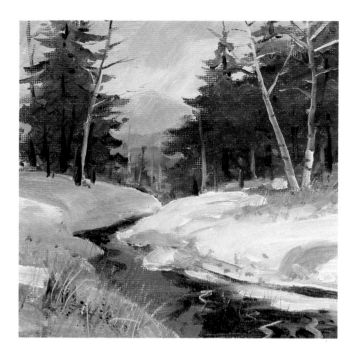

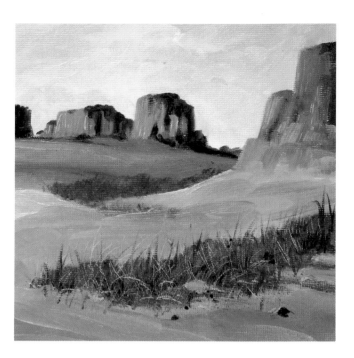

**Cool Picture, Warm Notes.** One good way to achieve color harmony is to choose *analogous* colors from one segment of the color wheel. Here, the artist works mainly with blues, greens, and blue-greens from one side of the wheel, then reaches across to the other side of the wheel to find a warm, complementary color for the dead weeds in the snow.

**Warm Picture, Cool Notes.** To reverse this strategy, you can choose your colors from a warm segment of the color wheel. In this desert landscape, most colors are chosen from the red, red-orange, orange, and yellow-orange part of the wheel. Then the artist jumps across the wheel to find a complementary, cool note for the foliage to provide a welcome note of contrast.

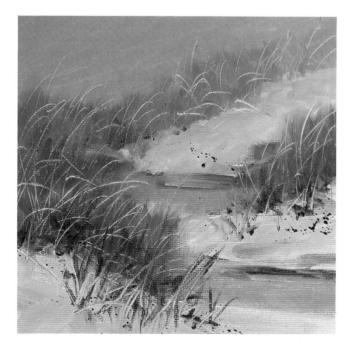

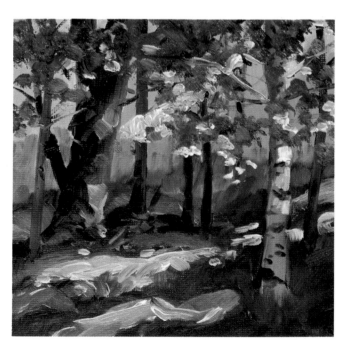

**Repeating Colors.** Harmony means unity. Another way to achieve unity is to interweave the same colors throughout the picture. The cool tone of the sky is repeated in the tide pools between the dunes, and is even reflected in the cool notes of color that appear in the sand. The sky colors alternate with the repeating bands of sand color. The cool color of the beach grass zigzags across the painting.

**Repeating Neutrals.** A subtle way to tie rich colors together is to interweave the bright colors with neutrals. Between the tree trunks, the artist has introduced warm and cool grays that reappear in the gaps between the foliage, on the foreground rocks and grass, and in the trunk of the birch at the right. The neutrals provide a unified setting for the diverse colors.

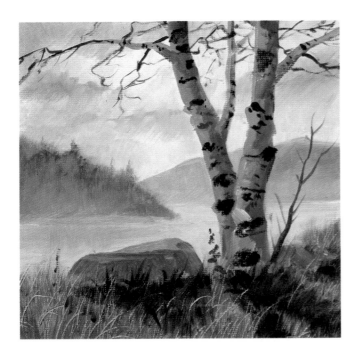

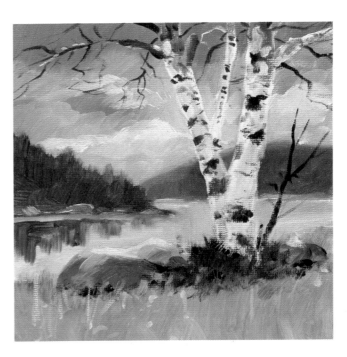

**Early Morning.** In the early morning, when the sun is low in the sky and the light hasn't reached its full brilliance, the landscape is often filled with delicate colors. You're apt to see soft yellows, yellow-greens, pinks, and violets. Here, the distant sun illuminates the lake and the far shore, while the tree and rock appear as dark silhouettes.

**Midday.** By the middle of the day, the sun has risen high in the sky, bathing the entire landscape in light and bringing out the full colors. The grass and foliage appear as rich yellows and greens. The early morning haze has disappeared, revealing the blues and whites of the sky and water. The sun brightens the top of the rock and illuminates the bark of the tree.

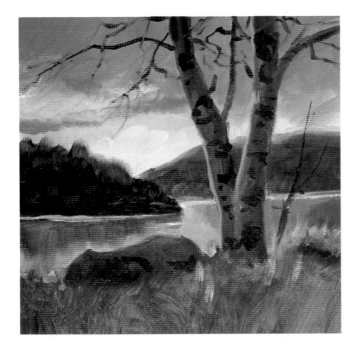

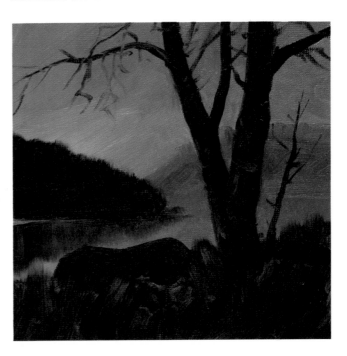

**Late Afternoon.** In late afternoon, the sun starts to sink behind the hills, throwing them into dark silhouettes. The tree and rock are also lit from behind and silhouetted. There's a strong contrast between the lights and shadows, as well as between the dark, upper sky and the brilliant sky at the horizon—repeated in the water.

**Night.** On a clear night, once your eyes become used to the darkness, you'll find that the moonlit sky can be filled with magical blues, greens, and violets. Similar colors can reappear in the landscape that receives the light of that sky. The moonlit sky is much lighter than the forms of the landscape, which are transformed into handsome silhouettes.

**Step 1.** To learn more about values, try a painting in which you work with just two colors, one warm and one cool, plus white. This *tonal painting* will depend heavily upon values, but this very limited palette can produce richer colors than you might expect. Here the artist places just burnt sienna, ultramarine blue, and white on the palette. Blending the two colors with turpentine, he outlines his composition on the canvas. Then with a large, flat bristle brush, he blocks in the sky with ultramarine blue and white, warmed with a touch of burnt sienna. As he works downward toward the horizon, he adds slightly more burnt sienna to the mixture to warm the sky color.

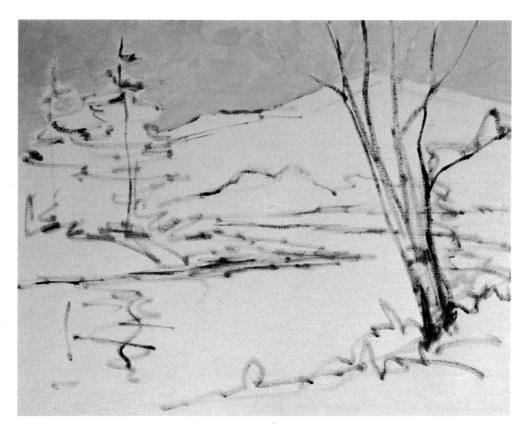

**Step 2.** The warm, but subdued color of the mountain is painted with the same three colors that appear in the sky, but now burnt sienna dominates. This time the mixture is cooled with a touch of ultramarine blue and lightened with white. Just as the sky contains some warm areas in which there's a bit more burnt sienna, the mountain contains some cool tones where the artist has added a bit more ultramarine blue to the mixture. Look at the sky and mountain closely: these areas contain lots of subtle variations, sometimes cooler and sometimes warmer, where the artist has varied the proportions of blue and burnt sienna in the mixtures.

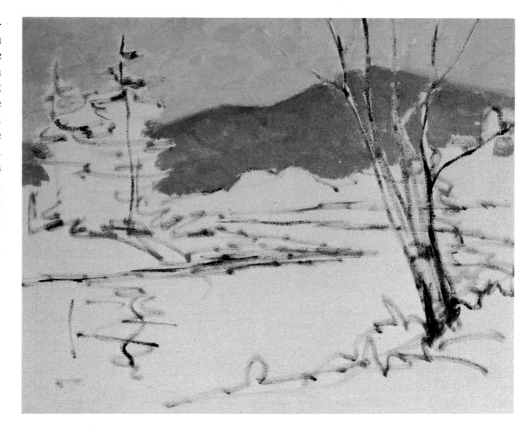

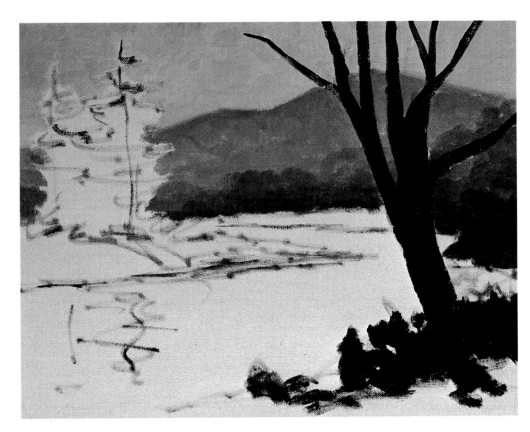

**Step 3.** Now the artist establishes the darkest note in the picture. Blending ultramarine blue and burnt sienna—without white—he picks up this mixture on a medium-sized bristle brush and paints the dark tree and the dark tone of the shore. Blending more white into this mixture and adding more blue, he suggests the dark trees at the foot of the mountain on the far shore. The artist has now established the four major values: the light value of the sky (to be repeated in the water), the dark value of the tree and nearby shore, the lighter middletone of the mountain, and the darker middletone of the distant trees.

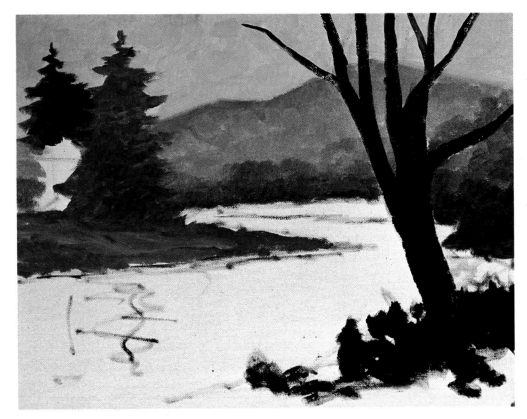

**Step 4.** So far, the artist has concentrated on the distance and foreground. Now he turns to the middleground. He blocks in the hot color of the dead evergreen and the shore beneath it with a mixture that's mainly burnt sienna, darkened here and there with a touch of ultramarine blue, and occasionally lightened with a hint of white. To the left, he begins to paint the shape of another evergreen with a mixture that's similar to the one he's already used for the trees at the base of the mountain. Half-close your eyes so that you see these two trees and the shore beneath them as values. They're the same dark middletone as the low trees on the distant shore.

**Step 5.** The artist finishes the dark tree at the extreme left, adding some of this color to indicate shadows beneath the trees and along the edges of the shore in the middleground. He carries the sky colors across the water. Because the water mirrors the sky, he places bluer mixtures in the foreground, gradually adding more white and a bit more burnt sienna as he moves into the middleground. The water in the center of the picture is mainly white—tinted with ultramarine blue and burnt sienna—to suggest the light of the sky shining on the bright water. The artist finishes blocking in the dark foreground with more of the color that he's already used on the dead evergreen.

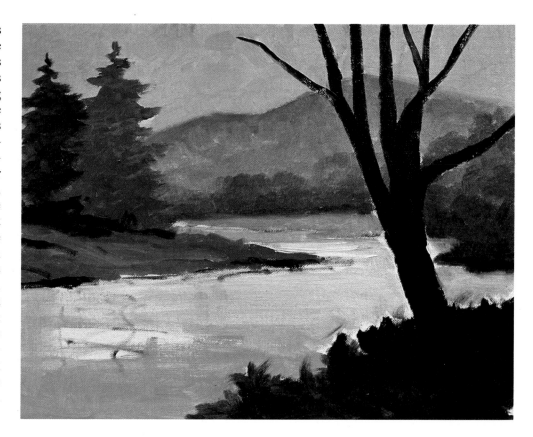

**Step 6.** The artist blocks in the foliage on the tree in the foreground. These dark, warm tones are mainly burnt sienna, darkened and cooled with ultramarine blue, and occasionally lightened with a touch of white. He uses a dark version of this same mixture to add another small tree trunk at the extreme right. Adding just a bit more white and an occasional touch of burnt sienna to the mixture, he blocks in the dark reflections of the trees in the water at the lower left. Notice how the reflection grows warmer beneath the hot color of the dead evergreen. With the same mixture used in the reflection, he adds a small evergreen to the middleground shore.

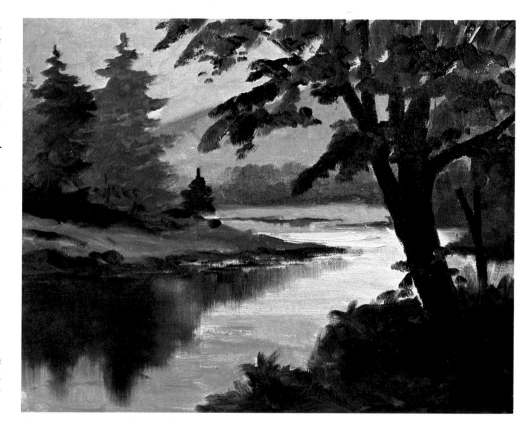

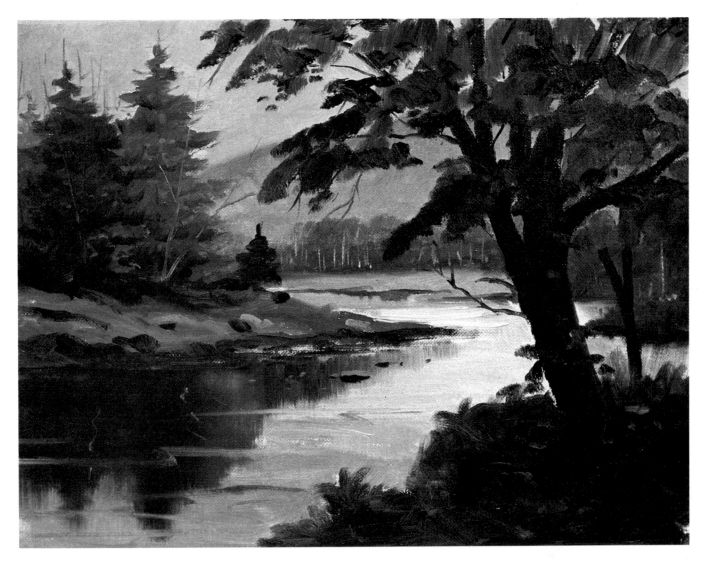

**Step 7.** It's always best to save texture and detail for the final step, as the artist does here. Working with the sharp point of a round, soft-hair brush, the artist adds more branches to the dark tree in the foreground and suggests a few individual leaves. He uses the same brush to indicate a few small rocks in the water and on the shore in the middleground. Rinsing the brush in turpentine and drying it on a scrap of newspaper, he picks up the pale mixtures used for the sky and the distant mountain and he adds lighter details, such as the ripples in the water at the lower left, the light-struck branches on the shore in the middleground, and the pale trunks of the trees on the distant shore. He also adds a few more branches to the evergreens at the extreme left, some touches of light on the shore beneath these trees, and even a few touches of light to the shadowy shore at the lower right. Looking at the finished painting, you may find it hard to believe that so much color was created with just ultramarine blue, burnt sienna, and white. Try such a limited palette for yourself and discover how many different mixtures you can make with the simplest possible means. You may even enjoy painting a series of pictures with different limited palettes, substituting the more brilliant phthalocyanine blue for the subdued ultramarine, or dropping blue altogether and switching to viridian, or putting aside burnt sienna in favor of the darker burnt umber. The whole secret of painting such a picture is to vary the *proportions* of all three tube colors in your mixtures. Thus, you not only create a full range of warm and cool mixtures, but you also produce a full range of values: dark, light, and two middletones, all carefully distributed throughout the painting for maximum variety.

**Step 1.** Blue, red, and yellow are called *primary colors* because they're the basic colors from which all other colors can be mixed—yet they themselves can't be mixed from other colors. Challenge yourself to see how many mixtures you can produce with a limited palette. It will turn out to be surprisingly versatile. This demonstration is painted entirely with ultramarine blue, cadmium red light, cadmium yellow light, plus white. The artist sketches the shapes of the basket and flowers with ultramarine blue, diluted with turpentine. He brushes in the background with a mixture of all three colors, plus lots of white, adding more blue for the shadowy tones at either side. The dark tone beneath the basket is just blue and red, with a hint of white.

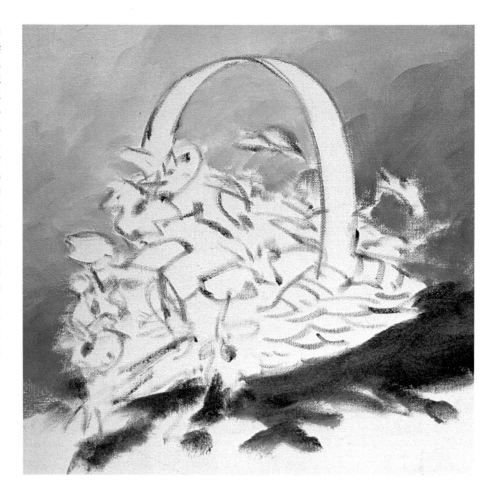

**Step 2.** The artist blends yellow and red, plus a bit of white, to create orange; then he subdues that orange with a hint of blue to create the color you see on the handle. More white is blended into the wet color for the lightest part of the curve. The dark underside of the handle is painted with the same shadow tone that appears in Step 1: blue and red. The two mixtures used to paint the handle are used again to paint the woven texture of the basket that emerges from the dark shadow in the lower right. Dark lines, suggesting the intricate detail of the woven basket, are painted with the shadow mixture and a small, pointed brush.

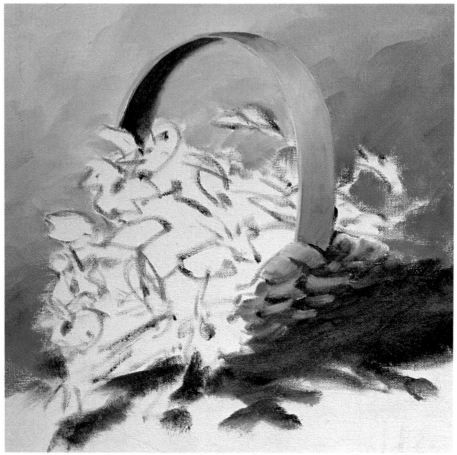

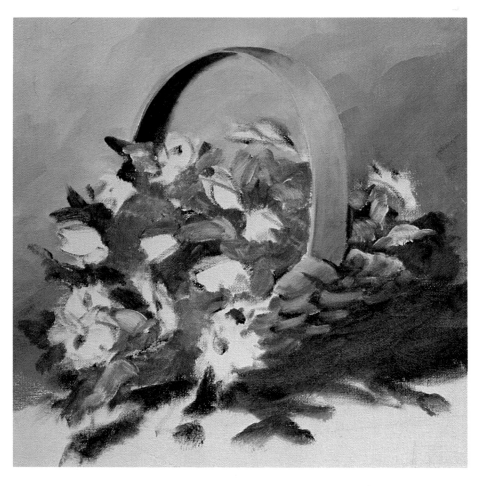

**Step 3.** The leaves, which are densely clustered within the basket, are blocked in with varying mixtures of blue, yellow, and white. Rather than use a smooth, even tone, the artist suggests the complex detail of the leaves by varied strokes that contain the blue-yellow mixture in different proportions. Some strokes contain more blue, while others contain more yellow. The darker strokes obviously contain less white, while the lighter strokes contain more. The artist works carefully around the shapes of the flowers, which, like the tablecloth, still remain bare canvas.

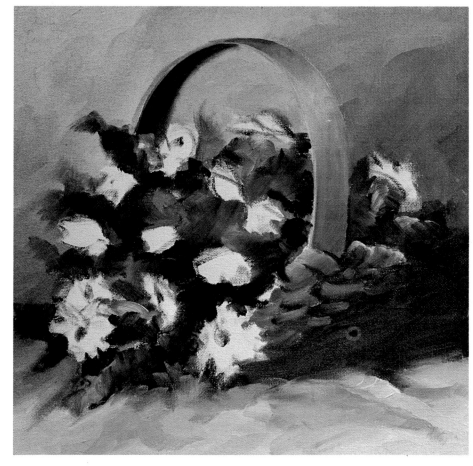

**Step 4.** Patches of shadow within the leaves are suggested by dark strokes of pure blue and yellow, occasionally warmed with a speck of red, but containing no white. To paint the tablecloth, the artist blends just a touch of the three primary colors with a lot of white for the paler areas. Then he adds more blue to this mixture for the shadows of the folds, which are occasionally warmed with an extra hint of red.

**Step 5.** The bright notes of the flowers are painted with thick strokes of pure yellow, plus a slight touch of red in the shadows. A few more touches of yellow are blended into the leaves to heighten their color here and there. At this stage, the only patches of bare canvas are the shapes of the white flowers.

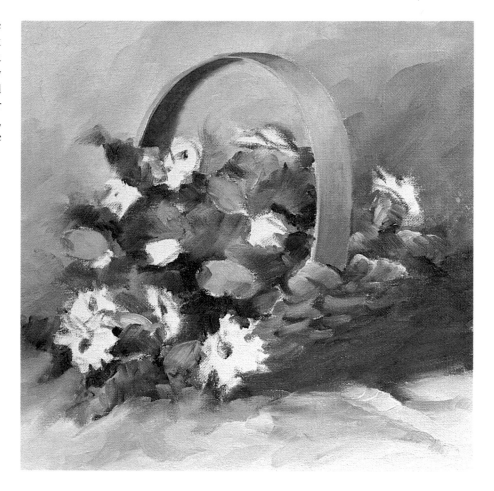

**Step 6.** The artist begins the white flowers with mixtures that may *look* like pure white, but actually contain just the slightest hint of all three primaries. The petals that catch the light are painted with thick white, slightly tinted with red and yellow. The petals in shadow are also painted with thick white, tinted with just a little blue and a speck of red. The brushstrokes radiate outward from the centers of the blossoms. The artist exploits the weave of the canvas to give his strokes a soft, ragged texture that matches the softness of the flowers.

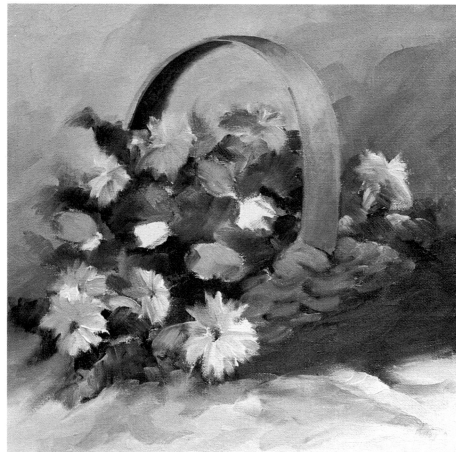

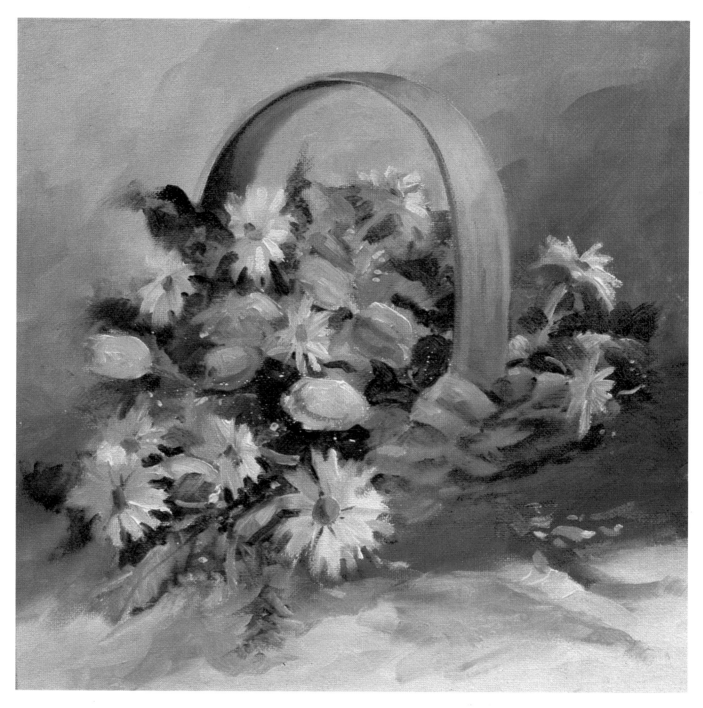

**Step 7.** The hot colors of the remaining flowers are painted with almost pure red, lightened with a touch of white and subdued by a hint of blue in the shadows. The warm centers of the white flowers are painted with red and yellow, with a touch of blue added for the dark notes. The artist completes the casual, sprawling bouquet by adding a few more white flowers and scattering some petals on the cloth that covers the table. He also reinforces the leaves with dark strokes of blue and yellow to strengthen the shadows, adding pale strokes of blue, yellow, and white to suggest more leaves caught in the light. With a small, round brush he picks up the dark shadow mixture of blue and red that appears beneath the basket to draw a few lines within the petals of the white flowers and to sharpen the edges of the flowers here and there.

The finished painting is ample proof that these three primaries—ultramarine blue, cadmium red light, cadmium yellow light, plus white—can create a full range of colors. Try painting a still life, then a landscape or seascape, with these three hues. Then try using other primaries. For example, a more brilliant primary palette might contain phthalocyanine blue instead of the subdued ultramarine blue, and you could substitute alizarin crimson for cadmium red light. You might also convert your subdued tonal palette—the ultramarine blue, burnt sienna, and white used for Demonstration 1—into a quiet primary palette by adding yellow ochre. Painting a series of pictures with various primary palettes is a wonderful way of learning how to mix colors.

**Step 1.** Now you're ready to try the full range of tube colors on your palette. But working with a full palette doesn't necessarily mean that you *must* paint a picture in brilliant colors. A full palette will work equally well for mixing the many muted colors in nature. In fact, it's a good idea to start out with a subdued subject, like this winter scene, to again force you to think about values. Here, in the first step, the artist brushes in the composition with ultramarine blue and a little burnt umber diluted with turpentine. Then he blocks in the sky with ultramarine blue, burnt sienna, yellow ochre, and white, blending in more yellow ochre and white as he moves to the right.

**Step 2.** The angular shape of the stream is painted with the same colors as the sky—ultramarine blue, burnt sienna, yellow ochre, and white—since the color of the water repeats the color of the sky. However, the artist changes the proportions of the mixture slightly, adding a bit more blue to the water and then adding more burnt sienna (but no white) to suggest the shadows at the edge of the shore. Blending more white into the water, he adds a few pale strokes that suggest the movement of the water. The distant mountain is painted with still another version of this mixture, now dominated by burnt sienna.

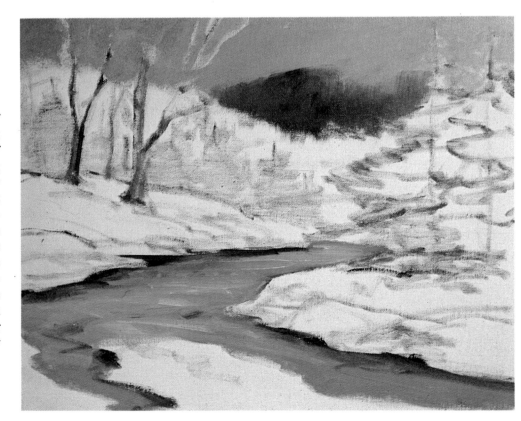

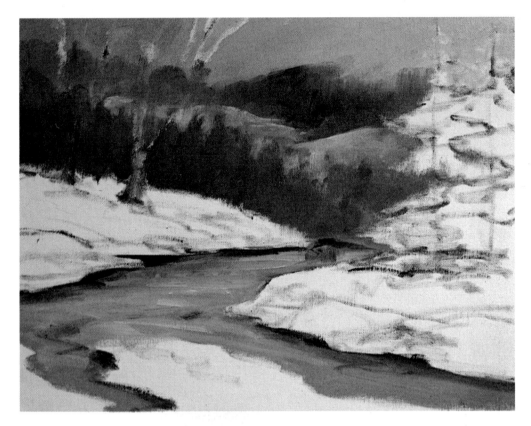

**Step 3.** The artist begins with the sky mixture—ultramarine blue, burnt sienna, yellow ochre, and white—to paint the strip of snowy slope beneath the distant mountain and above the diagonal row of shadowy trees. (Remember that snow is just another form of water, so it's also inclined to reflect the color of the sky.) Then he paints the shadowy row of trees, slanting down the snowy hill on the left, which is actually a combination of brilliant cadmium orange, subdued ultramarine blue, and burnt umber, plus white and an occasional touch of yellow ochre. This same mixture is used to paint the dark trees on the horizon, in the upper left-hand corner.

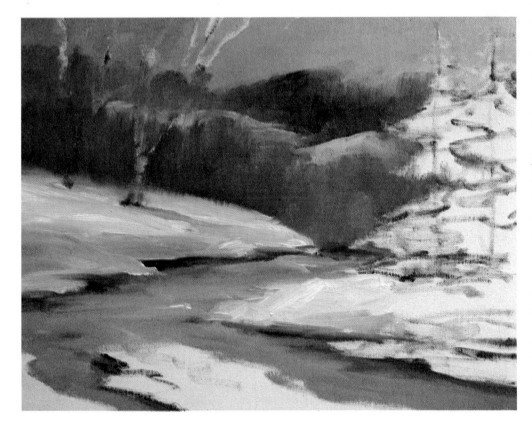

**Step 4.** The artist begins to work on the snow, starting with the triangular patch of shore in the middleground. He paints the sunlit top plane of the snow with a little cerulean blue and yellow ochre, mixed with a lot of white. (Cerulean blue is cooler and brighter than ultramarine blue.) Then he paints the shadows on the snow with ultramarine blue, a touch of alizarin crimson, burnt umber, and white. Although snow may *look* pure white, never paint it with solid strokes of white, used straight from the tube. The "white" snow is actually full of subtle color because it picks up so much reflected color from its surroundings and from the sky.

**Step 5.** The artist blocks in the rest of the snow with the same color combinations: cerulean blue, yellow ochre, and white for the sunlit top planes; and ultramarine blue, alizarin crimson, burnt umber, and white for the shadowy planes of the snowbanks. The dark tones of the evergreens are painted with another surprising combination of bright colors: cadmium orange and viridian, plus burnt umber for the darker tones and a touch of white for the lighter strokes. This color combination, carried downward into the stream, reflects the dark tones of the trees.

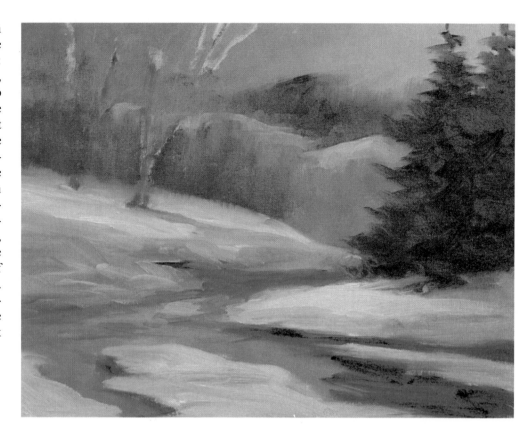

**Step 6.** At the left, the artist begins the dark trees with another interesting mixture of brilliant colors: cadmium red, viridian, burnt sienna, and a touch of yellow ochre. Adding a little white, he paints the distant tree trunks with a slender brush, varying the strokes by adding more white or yellow ochre. The dark rocks along the shore are the same mixture as the dark trees. Taking a second look, the artist decides that the water reflects its shadowy surroundings more than it reflects the sky. He repaints the stream with ultramarine blue, burnt umber, alizarin crimson, and a bit of white.

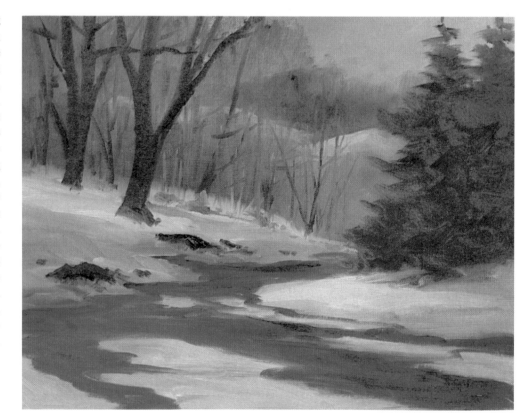

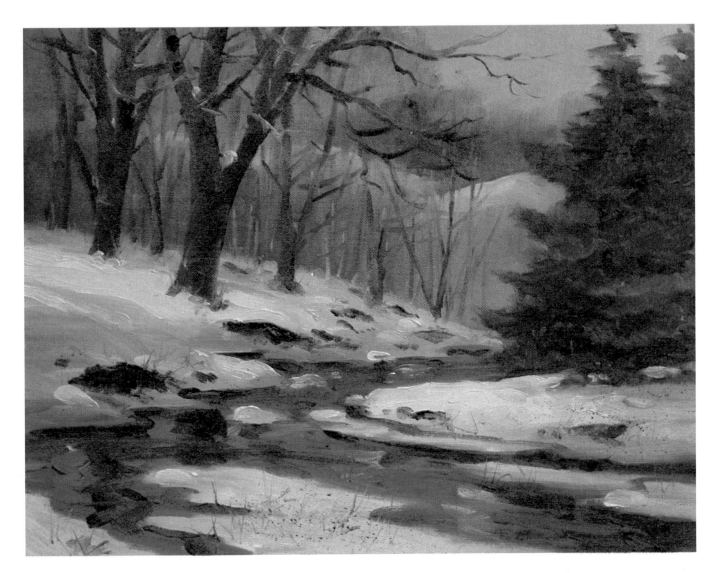

**Step 7.** In this final stage, the artist develops the detail of the foliage and branches, suggests some detail in the foreground, and builds up the darks and lights. Working with a slender brush, he adds more tree trunks, branches, and rocks with various combinations of brilliant colors that produce subtle darks: cadmium red, cadmium yellow, and phthalocyanine blue; cadmium orange, viridian, and burnt umber; cadmium orange, ultramarine blue, and burnt sienna. Minute changes in the proportions of these mixtures can produce interesting color variations. For example, a bit more cadmium orange adds a note of warmth to the mass of evergreens at the extreme right. An additional speck of cadmium red adds a hint of warmth to the shadowy mass of trees that moves down the distant slope at the left. To brighten the top planes of the snowbanks, the artist piles on thick strokes of white that's slightly tinted with cerulean blue and yellow ochre.

He uses the same mixture to add chunks of snow to the dark stream. And a few casual strokes of this mixture indicate the reflections of the snow in the dark water. The warm tones of the weeds, breaking through the snow in the foreground, are scattered strokes of yellow ochre, modified with a touch of burnt umber, and occasionally darkened with ultramarine blue. If you review the color mixtures used in this painting, you'll find that the artist has employed practically every color on his palette, from subdued hues like burnt umber and yellow ochre to the brilliant cadmiums, phthalocyanine blue, and viridian. Although the finished picture is a muted study of a snowy landscape on an overcast day, every one of these subtle mixtures contains interesting hints of rich color. Challenge yourself to paint a very quiet picture with mixtures of brilliant colors; it's one of the best ways to learn about color mixing.

**Step 1.** Painting an outdoor subject on a sunny day—perhaps a seascape like this one—will give you an opportunity to use your full palette to create richer colors. Try a gesso panel; your colors will look lighter and your strokes more distinct. Choosing a color that harmonizes with the overall color scheme, the artist draws the composition with ultramarine blue, subdued with a touch of burnt umber, and diluted with turpentine. He uses a big, flat bristle brush to block in the sky with ultramarine blue, cerulean blue, a hint of alizarin crimson, and white—adding more white for the cloud mass.

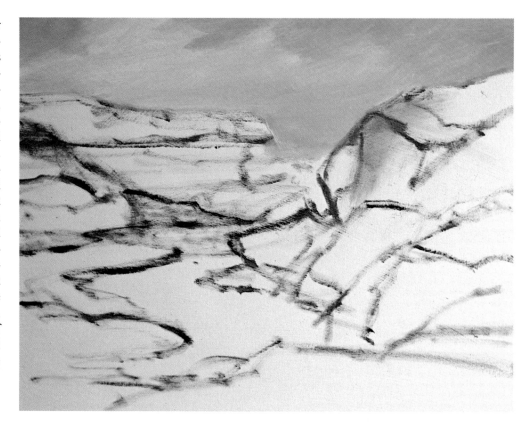

**Step 2.** The open sea normally reflects the color of the sky, and the water is often quite dark at the horizon. The artist indicates the dark, distant strip of ocean with the same mixture that he's used for the sky—but with less white. Where sunlight strikes the end of the headland at the horizon, he applies warm strokes of alizarin crimson and cadmium yellow, subdued with a touch of cerulean blue and lightened with white. The rest of the headland is cool and shadowy: the artist interweaves strokes of the warm, sunny mixture with cooler strokes of the sky mixture. Hints of warm color shine through the cooler tone of the shadow.

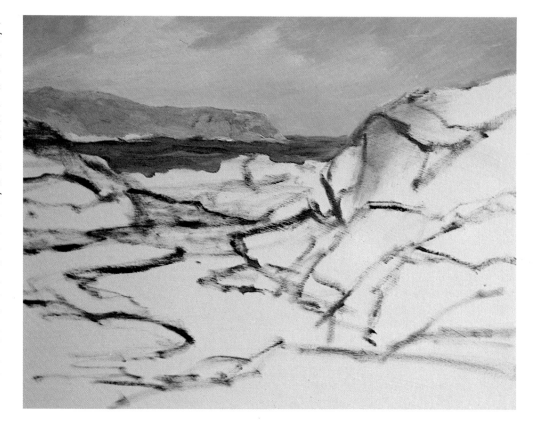

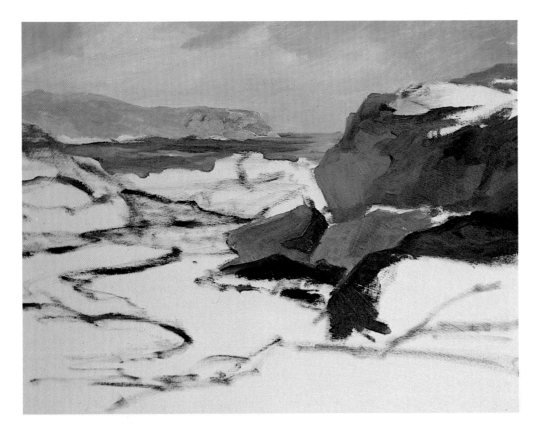

**Step 3.** Picking up his largest bristle brushes, the artist blocks in the dark tones of the foreground rocks. He concentrates on the shadowy areas, leaving bare canvas for the sunlit top of the largest rock. The strokes are various mixtures of alizarin crimson, ultramarine blue, burnt sienna, and white. The warmer strokes contain more crimson, while the cooler strokes contain more blue. On the seashore, the shadows of the rocks often pick up reflected colors from the water, which is why these shadows look so luminous. To increase their luminosity, the artist adds an occasional touch of yellow ochre.

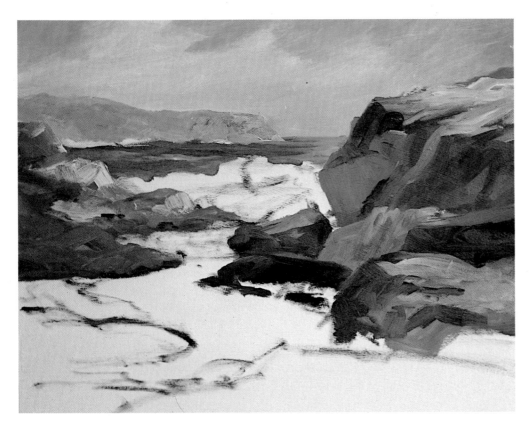

**Step 4.** The warmer colors of the rocks at the left are painted with various mixtures of cadmium red light, cadmium yellow light, burnt sienna, and yellow ochre, subdued by an occasional touch of ultramarine blue, particularly in the darks. The sunlit tops of the foreground rocks on the right are a mixture of cadmium red light and cadmium yellow light, which produces a stunning cadmium orange. This versatile mixture is easily subdued with a drop of cool color, such as ultramarine blue or viridian, and lightened with white—with an occasional cool note of the sky mixture.

**Step 5.** The bright, sunny tops of the rocks in the immediate foreground are again painted with cadmium red light and cadmium yellow light, subdued with a speck of ultramarine blue, and lightened with white. The darker tones on the foreground rocks contain more ultramarine blue. Now the entire panel is covered with wet color except for the foaming water between the rocks, which remains the bare, white surface of the gesso. As you look at the rocks—particularly those at the right—you can see how sharp and distinct the brushstrokes look on the smooth surface of the panel.

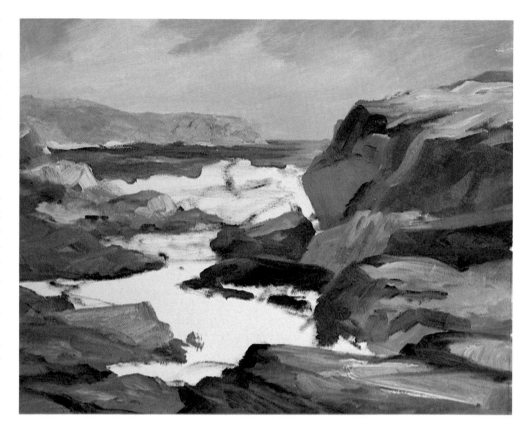

**Step 6.** Like snow, foam isn't pure white. Foam is water mixed with air, so it *behaves* like water, picking up reflected color. Therefore, under a blue sky, foam is apt to contain cool tones, as you see here. The artist paints the foam with big, rough strokes of white tinted with ultramarine and cerulean blues. Between the rocks, the foam also reflects the warm color of its surroundings, so the artist blends in delicate touches of the rock colors. With each stroke of foam, he varies the proportions of his mixtures, adding more or less white, so the strokes suggest light, shadow, and movement.

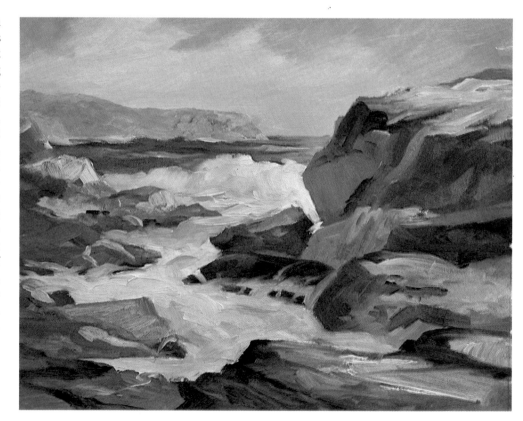

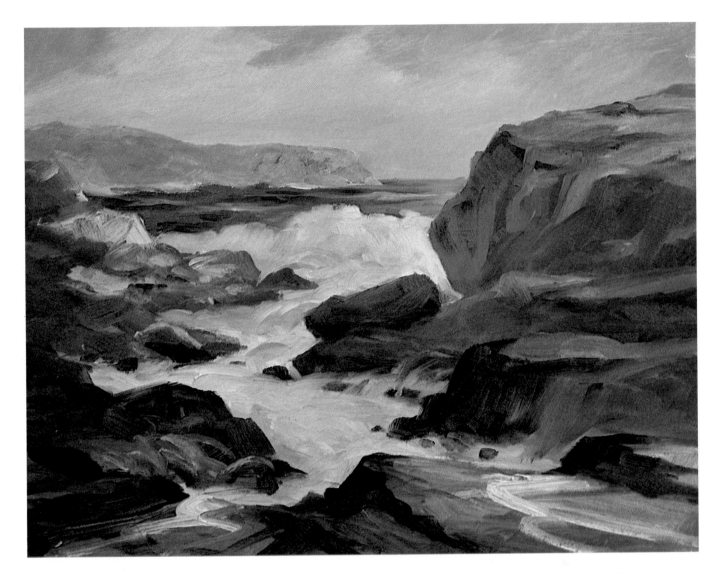

**Step 7.** The artist makes some interesting changes in the final stage of the painting. In the lower left-hand corner, he builds up and darkens the rocks, so now they're in shadow. He also strengthens the shadows on the rocks on both sides of the foaming water to dramatize the contrast between the dark rocks and the pale foam. These shadowy tones are various mixtures of cadmium red light, alizarin crimson, ultramarine blue, burnt sienna, and yellow ochre, plus white. Thus, there are warm strokes and cool strokes within the shadows, depending upon whether the mixture is dominated by cadmium red, alizarin crimson, or ultramarine blue. When the shadow tones become darker—as they do in the lower left—ultramarine blue and burnt sienna obviously take command. This mixture strengthens the shadow planes of the sunny rocks at the lower edge of the picture. Now the artist works with small bristle brushes to reshape the rocks and to modify the foam. Notice how he carries trickles of foam over the margins of the rocks and down into the lower left. He also uses the foam mixture to suggest the crests of the waves on the dark sea just below the horizon. Compare the finished rocks in Step 7 with the rocks in their unfinished state in Step 6. See how the rocks have become more shadowy, with the colors flowing more softly together. And study the subtle color mixtures within the rocks, which obviously reflect the cool tones of the surrounding water, while retaining the warm tones of the sun and the weathered stone. Although the artist has used a full range of rich colors in this seascape, he's carefully avoided the temptation to make every mixture equally bright. The picture is successful because there's a carefully planned interplay of bright and subdued colors. The muted (but still colorful) tones of the shadowy rocks dramatize the sunlit foam and the bright tops of the rocky slopes.

**Step 1.** The first four demonstrations show four methods of *direct* painting, which means painting in one continuous operation, and aiming for the final effect from the very beginning. But that's not the only way. The Old Masters often painted in separate operations that they called *underpainting* and *overpainting.* The simplest way to do this is to paint the entire picture in tones of gray or brownish gray, let this monochrome underpainting dry, and then add color in a separate overpainting. In this demonstration, the artist sketches his composition with a mixture of ultramarine blue and burnt umber. He uses the same combination, plus white, to paint the brick wall.

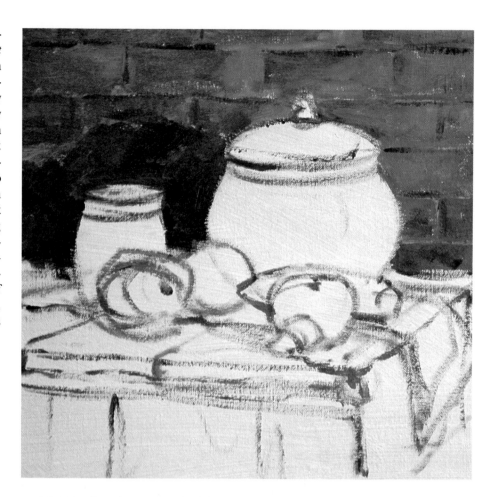

**Step 2.** The artist continues to work with ultramarine blue and burnt umber, adding more white for the big covered jar and the small jar on the left. He uses a dark value to paint the cucumber, its shadow, and the table edge. Then he adds white to the areas struck by light—the top of the cucumber and right side of the table—leaving the original dark tones in the shadow areas. To paint the drapery, he adds still more white. To make certain that the same tone appears throughout the underpainting, the artist has premixed a large quantity of it on his palette. To modify it, all he has to do is add different amounts of white.

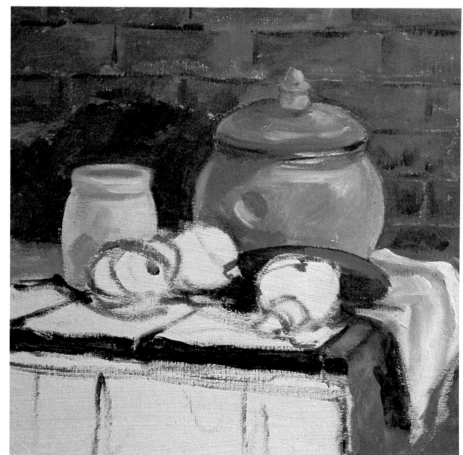

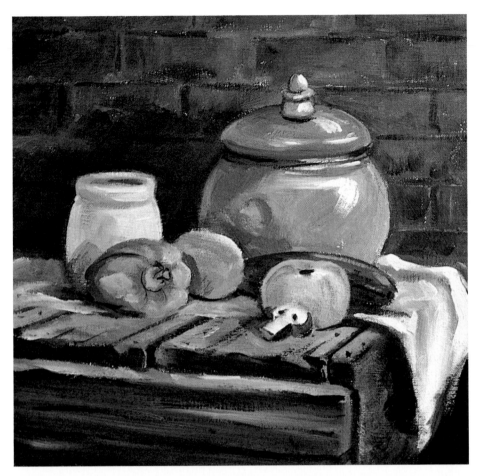

**Step 3.** He completes the underpainting by executing the forms of the fruits and vegetables, the shapes and textures of the weathered wood, and such details as the strong touches of light and shadow on the jars, the drapery, and the other objects on the table. The finished underpainting is entirely a study in values, similar to a black-and-white photograph of the subject. When the underpainting is dry, the artist is ready to begin overpainting. The underpainting has been executed with just three tube colors—blue, umber, and white—diluted with the simplest painting medium: a 50–50 mixture of linseed oil and turpentine.

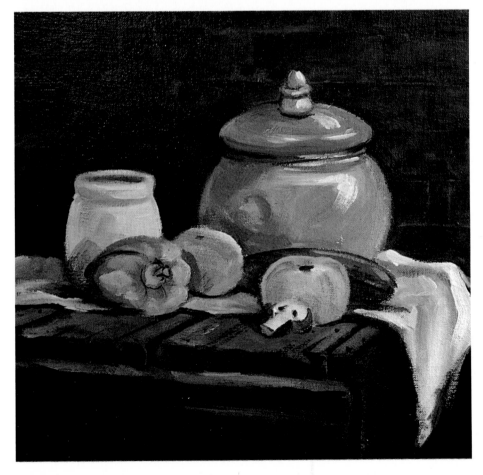

**Step 4.** Now the artist switches to one of the resinous painting mediums that you read about earlier. He blends cadmium red light, alizarin crimson, and burnt umber on his palette, and thins this blend with painting medium until the mixture is smooth and transparent. This *glaze* is brushed over the bricks with a flat, soft-hair brush. In the same way, the wooden table is glazed with a transparent mixture of yellow ochre, burnt sienna, a speck of alizarin crimson, and resinous painting medium. The monochrome underpainting of the bricks and wood shines through these glazes, which are like thin sheets of colored glass.

**Step 5.** The big, covered pot is now overpainted with a glowing glaze of cadmium red light, cadmium yellow light, and resinous painting medium. The monochrome underpainting, with its sharp, linear details and glowing highlights, still shows clearly through the transparent overpainting. Obviously, the brilliant colors of the overpainting become more subdued as they form optical mixtures with the monochrome underpainting. The artist can control the darkness or lightness of the overpainting by adding more or less medium. He can also brush more wet color onto the canvas to make the glaze darker. And he can wipe away some wet color with a rag—as he does here to accentuate the highlights on the jar.

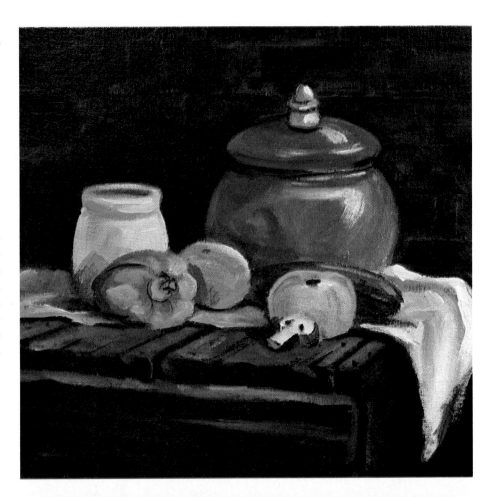

**Step 6.** The artist glazes the dark form of the cucumber with a transparent mixture of ultramarine blue and cadmium yellow light, diluted with resinous painting medium. To contrast with this subdued green, he mixes a bright glaze of cadmium red light and alizarin crimson on his palette, and brushes this mixture over the tomato. The cucumber has been underpainted in a dark monochrome, so the overpainting remains dark and subdued. But the tomato is underpainted in a pale monochrome that allows the bright glaze to sing out.

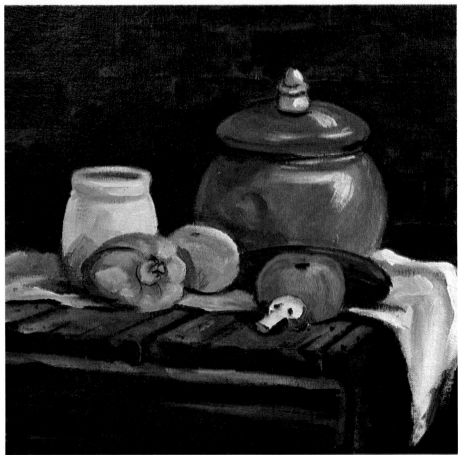

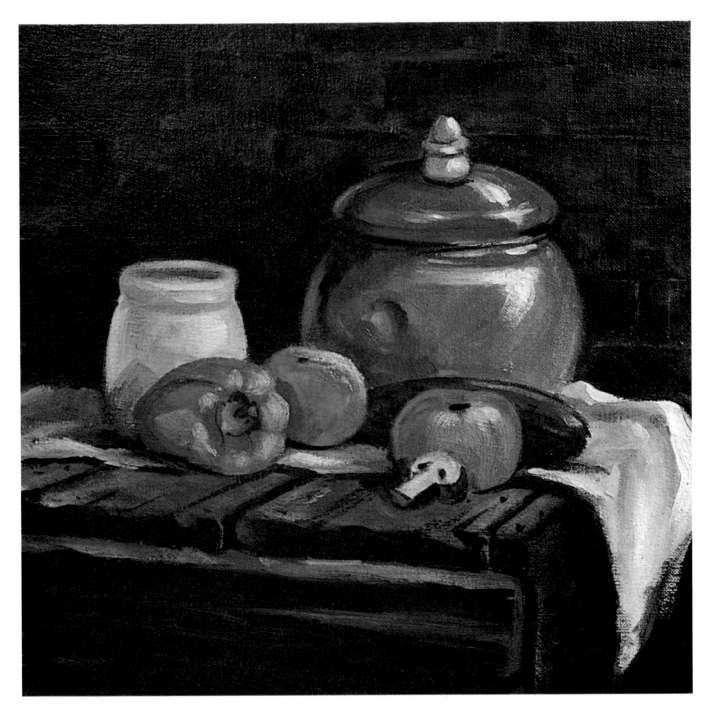

**Step 7.** The pepper is glazed with cadmium yellow light and ultramarine blue. The orange is glazed with cadmium red light and cadmium yellow light, plus a tiny hint of white that makes the glaze semitransparent rather than absolutely transparent. The small jar and the knob on the top of the big jar are both glazed with cerulean blue. The drapery is glazed with a delicate mixture of ultramarine blue and alizarin crimson, with lots of painting medium. The artist then adds a small amount of white to each of the glaze mixtures and adds more touches of light to each object. You can see these touches most clearly on the pepper, orange, and tomato. He brushes burnt sienna over the sliced mushroom in front of the tomato, wipes away some wet color from the lighted edge of the table, darkens the shadow side of the big pot and the round indentation on the side of the pot, and wipes away some of the glaze on the big pot to suggest cool reflections. This method of underpainting and overpainting has obvious advantages. You can concentrate entirely on difficult problems of form in the underpainting; then, when the underpainting is dry, you can concentrate entirely on the color. And this kind of color has a unique character, quite different from direct painting: transparent glazes give your picture a magical depth, atmosphere, and inner light.

**Step 1.** Having tried a mono-chrome underpainting followed by an overpainting in transparent color, you should certainly try a picture in which both the underpainting and the overpainting are in color. It's best to start with a limited color underpainting—a simple underpainting in just a few colors. The artist demonstrates a limited color underpainting in this study of dunes and beach grass beneath a cloudy sky with the sun breaking through. The preliminary brush drawing is executed in burnt umber, diluted with plenty of turpentine.

**Step 2.** The whole idea is to underpaint with colors that will form interesting optical mixtures with the overpainting. The artist underpaints the sky with yellow ochre and white, blending in more white as he approaches the horizon. He underpaints the shadowy side of the big sand dune with ultramarine blue and white. The top of the dune is underpainted with a dark mixture of ultramarine blue and burnt umber. He begins to darken the beach grass at the bottom of the dune with burnt umber, yellow ochre, ultramarine blue, and white. And he starts to brush a pale mixture of alizarin crimson and white over the sand.

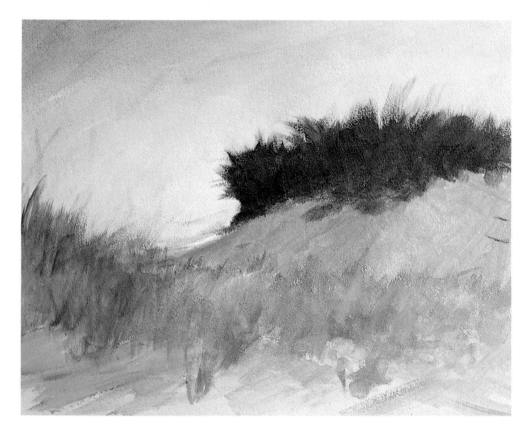

**Step 3.** The artist continues to build up the underpainting of the beach grass with alizarin crimson, cadmium yellow light, a little burnt umber, and white. Then he brightens the underpainting of the sand with a more vivid mixture of alizarin crimson and white. Moving up to the beach grass at the top of the dune, he darkens this with a dense mixture of ultramarine blue and alizarin crimson. The limited color underpainting is allowed to dry before the artist goes on to the overpainting. The underpainting has been executed with just a few colors, diluted with a 50–50 mixture of turpentine and linseed oil.

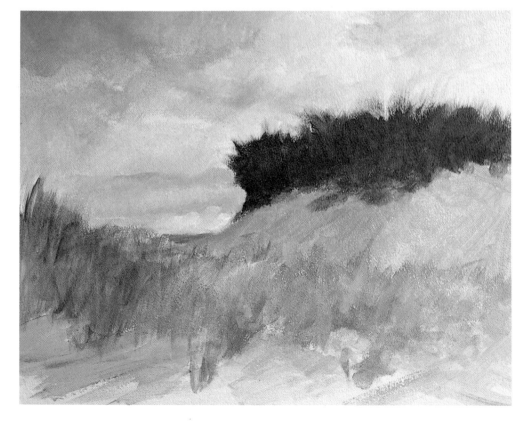

**Step 4.** The artist blends phthalocyanine blue with a touch of burnt umber and a fair amount of white. He then dilutes this mixture with a resinous painting medium. The result is not a transparent glaze, but a semitransparent mixture called a *scumble.* He brushes this mixture over the sky with a back-and-forth, scrubbing motion that creates a bluish haze over the warm underpainting. In some places, the artist brushes in more blue, more white, or more painting medium to make the scumble thinner. The result is a cloudy sky with patches of blue and warm sunlight shining through. The semitransparent scumble reveals the warm underpainting.

**Step 5.** A colorful haze of yellow ochre, alizarin crimson, and white is scumbled over the cool, shadowy underpainting on the dune. Thinned to a semitransparent consistency with resinous painting medium, the mixture is scrubbed on thinly to allow the cool undertone to come through. A thin, semitransparent mixture of cadmium red and cadmium yellow light is scumbled over the dark tone of the grass at the top of the dune. Then, a thick, opaque version of that same mixture (which really looks like cadmium orange) is picked up on the tip of a round, soft-hair brush to indicate blades of beach grass caught in bright sunlight.

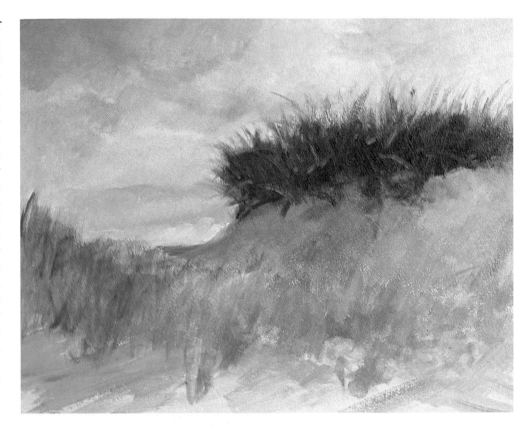

**Step 6.** Over the hot underpainting in the sandy foreground, the artist brushes a pale scumble of yellow ochre and white, forming an optical blend that expresses the sunny character of the sand. Over the warm underpainting of the beach grass in the foreground, the artist glazes a transparent dark mixture of cadmium yellow, cadmium red, and ultramarine blue, diluted with resinous medium to allow the vivid underpainting to shine through. A dense, opaque mixture of yellow ochre and white indicates the sunstruck blades of beach grass.

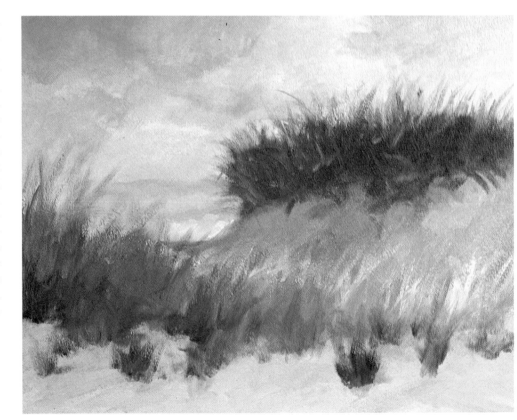

**Step 7.** While the overpainting is still wet, the artist adds the final details and textures with small brushes. He adds more blades of sunstruck beach grass with slender, opaque strokes of yellow ochre and white. With ultramarine blue and alizarin crimson, diluted to a liquid consistency with resinous painting medium, he adds the tiny dark touches among the beach grass in the foreground. Then he thins this mixture to transparency with more painting medium and brushes in the shadows that are cast by the beach grass across the sand. He blends some white into this mixture to add dark textures to the shadowy face of the big dune. Comparing the finished paint-ing with the completed underpainting in Step 3, it's fascinating to see how the harsh colors of the underpainting gradually form optical mixtures with the overpainting to produce softer, more realistic colors. It's also important to learn the differences between glazes and scumbles. As you've seen in Demonstration 5, a glaze is like a transparent sheet of colored glass. A scumble, on the other hand, is more like a colorful haze. Each of these overpainting mixtures has a special way of forming optical mixtures with the underpainting—which you'll get to know by experience.

**Step 1.** One of the delights of underpainting and overpainting is that you can plan the underpainting as carefully as the artist did in Demonstration 6, or you can rely on your imagination, mixing your colors intuitively "just to see what happens." In this demonstration, the artist takes the intuitive route. He brushes in the lines of this autumn landscape with ultramarine blue, which will contrast, not harmonize, with the final colors in the painting. He also lets his imagination roam as he begins to block in the colors of the underpainting with broad, casual strokes.

**Step 2.** As this accidental-looking underpainting proceeds, a certain logic appears. The artist underpaints the dark tree trunks and foliage with colors that should produce interesting optical mixtures with a warm overpainting. And he paints the distant mountain with a warm color that should create an interesting optical mixture with a cool overpainting. Beyond the trees, there's a variety of warm patches that will reinforce the overpainting for the warm foliage. The sky is underpainted in warm colors that will enrich the cool overpainting of the sky.

**Step 3.** The colors of the finished underpainting certainly aren't those of an autumn landscape, but you now can see all the major pictorial elements. *Nothing* in the picture is really the final color, but all these strange underpainting mixtures are meant to stimulate the artist to invent overpainting colors that will create lively optical mixtures. Most of the warm tones here are blends of cadmium red, cadmium yellow, burnt sienna, and white. Most of the cool mixtures contain ultramarine blue, viridian, and burnt umber.

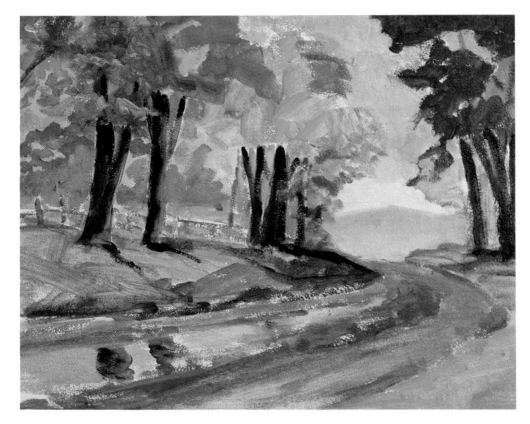

**Step 4.** When the underpainting is dry, the artist begins the overpainting. With a resinous medium he scumbles cerulean blue, yellow ochre, and white over the sky, permitting some of the underpainting to show through. He then scumbles cerulean blue and white over the warm underpainting of the mountain to produce a cool optical mixture. In the upper left, the artist begins to brush rough glazes and scumbles of cadmium red and cadmium yellow over the underpainting. The artist darkens the tree trunks by glazing burnt sienna over the cool underpainting.

**Step 5.** The artist scumbles cadmium red and cadmium yellow, blended with some white, over the foliage and it suddenly emerges in its true autumn colors. However, these colors are obviously enlivened by the underpainting, which still shines through. Some of the cool underpainting becomes patches of sky shining through the leaves. The dark underpainting of the foliage in the upper right forms a lively, irregular optical mixture with the overpainting, suggesting an intricate pattern of lights and shadows on the leaves.

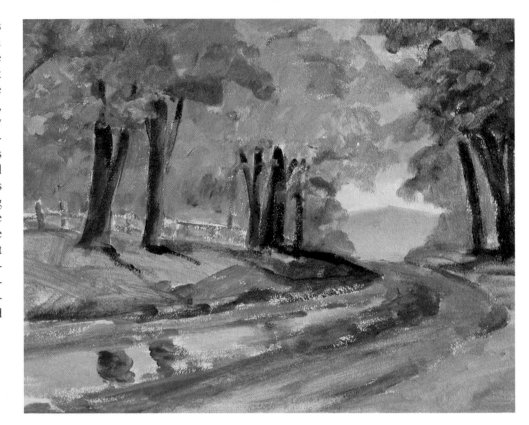

**Step 6.** Over the generally cool underpainting of the foreground, the artist glazes and scumbles cadmium red, cadmium yellow, and burnt sienna—alternating transparent and semi-transparent strokes. Now it's obvious that the earth is covered with autumn leaves and other debris typical of the season. The tree trunks are solidified with glazes of phthalocyanine blue and burnt sienna. This mixture is diluted with more painting medium and carried upward to suggest the cluster of shadowy leaves in the upper left. More strokes of cadmium red, cadmium yellow, and burnt sienna appear throughout the foliage.

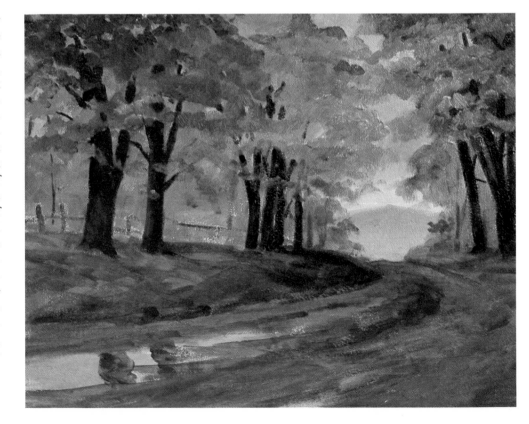

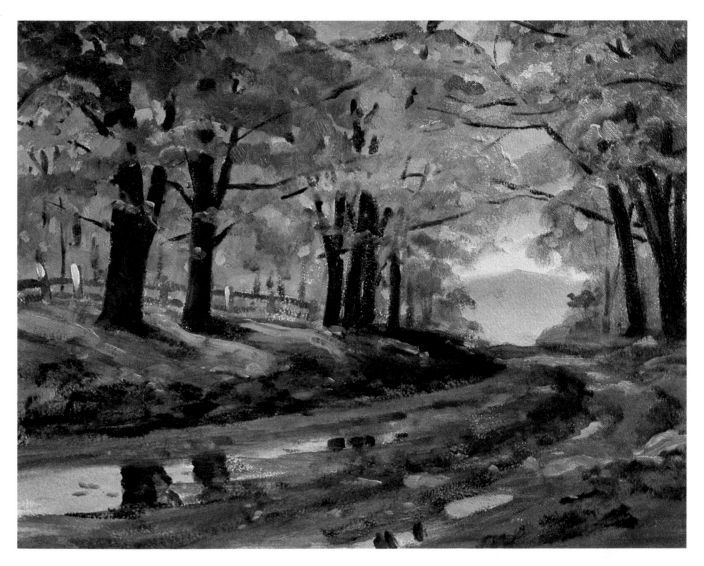

**Step 7.** The artist completes the painting by strengthening the darks and lights. With a fluid mixture of phthalocyanine blue and burnt sienna, he adds more branches to the trees, adds shadows along the edge of the road, and darkens the reflections of the trees in the puddles. With thick, opaque strokes of cerulean blue, warmed with a touch of yellow ochre and lightened with white, he punches more "sky holes" into the foliage and then brightens the puddles in the foreground. More opaque touches of cadmium yellow, with just a little cadmium red and white, add the sparkle of sunlight to the foliage and suggest patches of sunlight on the ground. Having seen the strange, unrealistic colors of the underpainting, you may be surprised to find that the finished painting is a realistic image of the colors of autumn. Look closely at the finished painting, and you'll see hints of the underpainting colors in almost every area of the canvas. Although the casual observer would never notice the underpainting, *you* know that it adds great vitality to the optical mixtures that produce these vivid color effects.

**Step 1.** So far, with the exception of one demonstration on a smooth gesso panel, these oil painting demonstrations have been done on canvas. Now this demonstration shows you an underpainting technique that takes advantage of a really *rough* painting surface. The artist coats a hardboard panel with thick, rough strokes of gesso that retain the imprint of the brush. When the gesso is dry, the artist draws the outlines of his composition with burnt sienna, diluted with turpentine. (His strokes obviously reveal the roughness of the painting surface.) He then blocks in the sky with cerulean blue, a little yellow ochre and a lot of white, gradually blending in more white as he nears the horizon.

**Step 2.** Thinning burnt sienna to a transparent consistency with plenty of turpentine, the artist washes this warm color over the tree trunk and branches. The purpose of this operation is to define the silhouette more clearly—preparatory to the next step. In the lower left-hand corner, the artist suggests a distant mountain with a mixture of ultramarine blue, alizarin crimson, yellow ochre and white. The rocky foreground remains bare gesso.

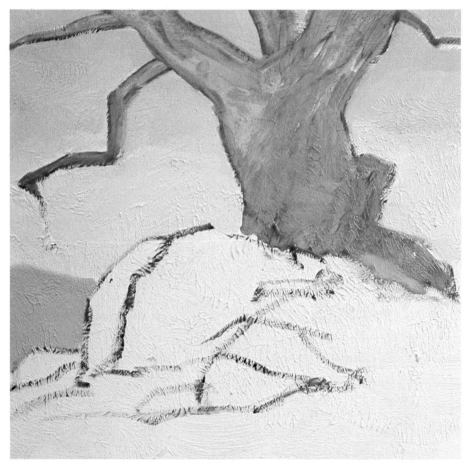

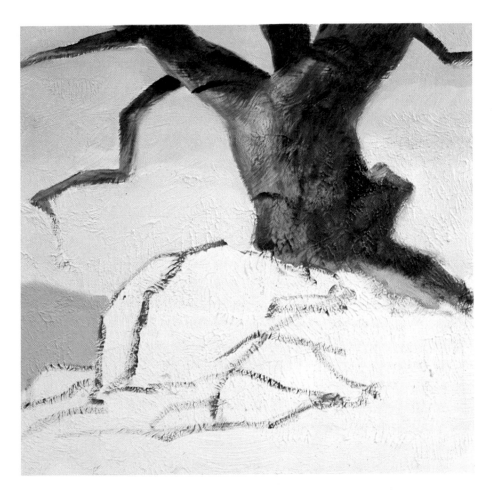

**Step 3.** With a dark mixture of burnt sienna and ultramarine blue, the artist uses a technique called *drybrush.* He holds his brush at an angle and moves it lightly back-and-forth over the trunk and branches. As the brush touches the raised texture of the rough gesso, liquid color is deposited on the irregular ridges of the painting surface. He gradually presses harder on the brush, depositing more color in certain areas to suggest dark shadows. Now the entire trunk and branches have the ragged texture of bark—which is why the artist has chosen this textured gesso panel. With a smaller brush he strengthens the branches and draws shadow lines on the trunk.

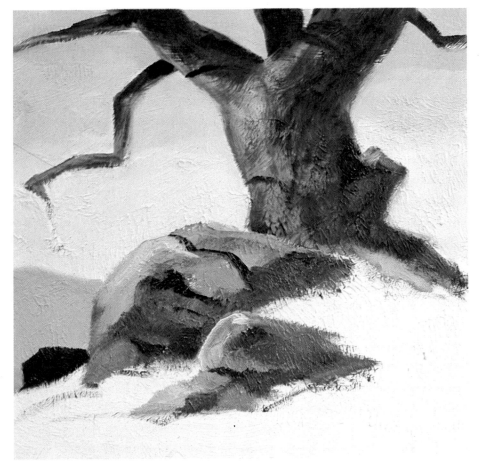

**Step 4.** With various mixtures of phthalocyanine blue, burnt sienna, yellow ochre, and white, the artist blocks in the lights and shadows of the rocks. The sunlit top planes contain more white and yellow ochre. There's more burnt sienna and phthalocyanine blue in the shadowy side planes . The cracks in the rocks are pure burnt sienna and phthalocyanine blue—as is the dark silhouette of the rock in the lower left. This is the finished underpainting. The artist lets the paint dry thoroughly before he goes on to the overpainting.

**Step 5.** Over the dried underpainting of the trunk and branches, the artist paints a glaze of burnt sienna with a hint of cadmium red light in the warmer areas and a little ultramarine blue in the cooler areas. (The color is thinned with resinous painting medium.) While this glaze is wet, the artist scrapes the trunk with his palette knife, taking color off the ridges to accentuate the ragged texture of the bark. The shadows on the snow are painted with ultramarine blue, alizarin crimson, yellow ochre, and white. Just a hint of this mixture is added to pure white for the lighted areas of the snow. The artist adds more shadows to the trunk and branches.

**Step 6.** The artist mixes a thick blend of cerulean blue, burnt sienna, yellow ochre, and white with his palette knife. Then he picks up this mixture with a painting knife—a knife with a specially designed, flexible, diamond-shaped blade—and carries the thick, pasty color over the lighted planes of the rocks. The color is caught by the rough texture of the gesso, so these strokes now have the ragged texture of the rocks themselves. Darkening this mixture with more cerulean blue and burnt sienna, the artist repaints the shadow planes with similar strokes. With a small, pointed brush he paints the cracks in the rocks with phthalocyanine blue and burnt sienna.

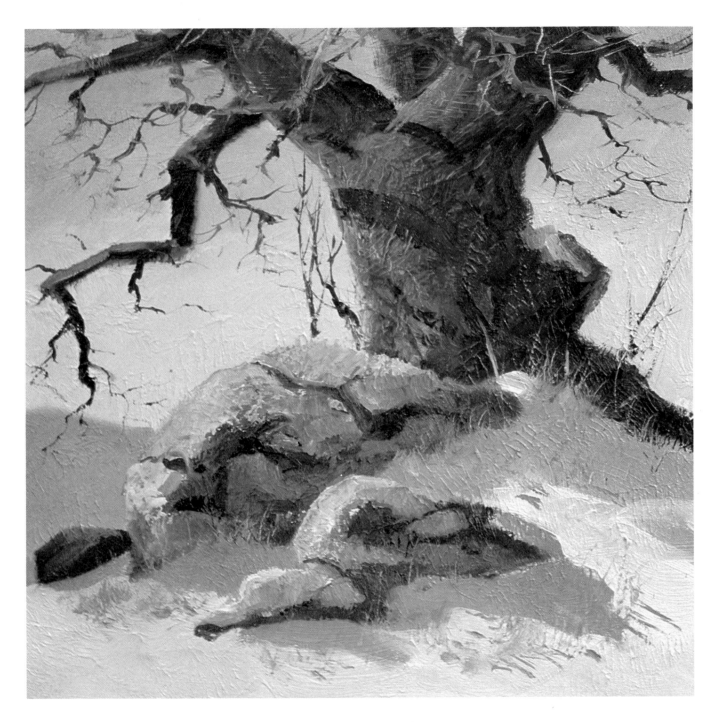

**Step 7.** To make the texture of the trunk even more obvious, the artist uses the side of his palette knife blade to scrape away more color from the ridges of the gesso panel. Picking up a very small amount of phthalocyanine blue and burnt sienna on a brush that's *damp*—not wet—with color, the artist strengthens the darks of the tree trunk with more drybrushing. He moves the damp brush lightly back-and-forth over the rough painting surface so that the bristles touch only the peaks and skip the valleys. Thus, the shadowy areas of the bark gradually grow darker and rougher. With a slender, pointed brush, he adds dark branches and twigs to the tree using a fluid mixture of phthalocyanine blue, burnt sienna, and paint-ing medium. With a similar brush he adds lighter twigs and branches with cérulean blue, burnt umber, yellow ochre, and white. Wispy strokes of yellow ochre, burnt umber, and white are scattered across the foreground to suggest dead weeds in the snow. And the tip of a tiny brush is used to add the delicate shadow lines of the weeds with the same mixture used for the shadows on the snow: ultramarine blue, alizarin crimson, yellow ochre, and white. Studying the finished picture, you can see why the artist prepared this rough painting surface to suit the subject. He's used the irregular texture of the thick gesso to convey the weathered bark of the old tree and the granular surface of the rocks.

**Step 1.** In the first four demonstrations, you've seen how to mix colors on your palette. But another interesting approach is to start mixing colors on the palette and then continue to mix them on the canvas. Because the colors flow into one another on the painting surface, you achieve an almost instant color harmony. The artist begins with the usual brush drawing—in ultramarine blue and alizarin crimson. The brush lines will disappear as soon as the canvas is covered with wet paint, but the drawing stamps the design of the picture in the artist's memory.

**Step 2.** On the palette, the artist creates various mixtures of ultramarine blue, phthalocyanine blue, cadmium red, cadmium yellow, and yellow ochre, all softened with a great deal of white. He then brushes these tones over the entire canvas, letting all the colors fuse into one another. At first glance, the canvas seems like a haze of random strokes, but the strokes do follow some logic: the artist remembers that the cool tones of the water belong at the bottom of the canvas, while there's a brightly lit area in the center of the sky.

**Step 3.** Keeping the original drawing fixed firmly in his mind, the artist begins to blend more color into the wet surface of the canvas. He adds soft, blurred strokes of cadmium red and cadmium orange to the sky, and then he makes sure that these colors are reflected below in the area of the water. He darkens the water with more phthalocyanine blue—using this powerful color in very small quantities so that it won't obliterate the other mixtures. There are still no definite forms in the painting, but you begin to sense the presence of sky and water.

**Step 4.** At last, the first concrete form appears in the painting. It's the distant mountain that the artist has indicated in the original brush drawing. The shape is painted with ultramarine blue, alizarin crimson, and a little white, first mixed on the palette and then blended carefully into the wet color on the canvas. With long, horizontal strokes, the artists melts the lower edge of the mountain into the color below. That mountain makes us see the warm color above as sky, and the color below as misty water. Going over these areas with a big brush, the artist blends the colors more softly. Some of the harsh tones of Step 3 begin to fade.

**Step 5.** After combining burnt sienna, viridian, and a little cadmium orange on the palette, the artist brushes this into the middleground, just beneath the mountain, to create a wooded island. He carries a few strokes down into the water to suggest the reflection. He then picks up burnt umber, ultramarine blue, and viridian on his brush for the dark silhouette of the island on the left, its reflection, and the dark mass of foliage above. As each color is added to the picture, it mixes with the color that was placed on the canvas earlier. With a small brush he adds lines of yellow ochre and white to suggest shining white streaks in the water.

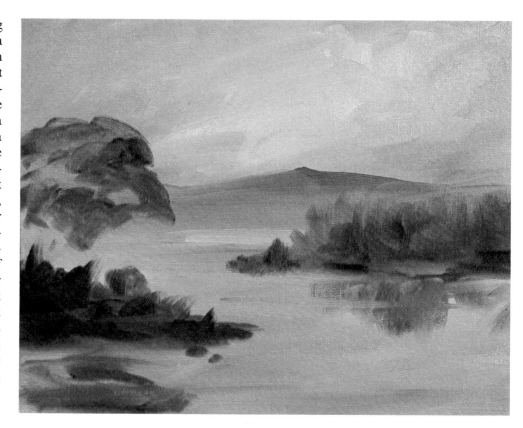

**Step 6.** The artist builds up the form of the big tree and the island at the left with thick strokes of ultramarine blue, viridian, and a touch of cadmium orange for warmth. The island is extended further into the water, and the tone of the land is darkened to match the tone of the tree. The reflection in the water is darkened for the same reason. A few streaks of cerulean blue, viridian, and white are carried across the reflection to suggest the light on the water. These dark tones in the left foreground are warmed by the underlying color that merges with the fresh brushstrokes.

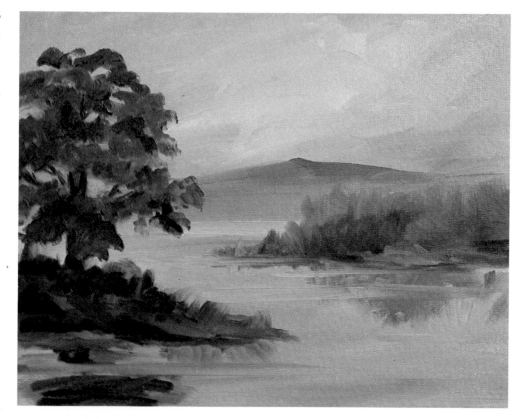

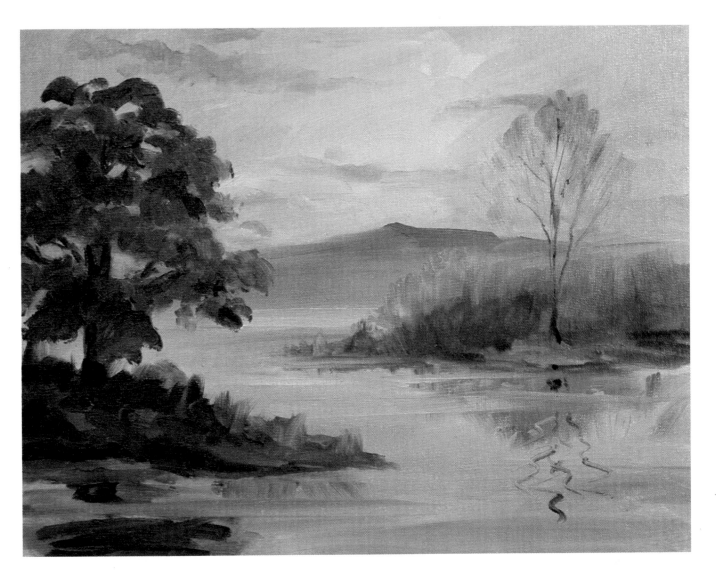

**Step 7.** To lighten the tone of the sky, the artist blends more yellow ochre and white into the wet, underlying color. Slightly darker, wispy clouds are brushed in with cerulean blue, alizarin crimson, and white. A touch of burnt umber is added to this mixture for the soft, almost transparent foliage of the slender tree on the right. Its twigs and the clouds merge with the underlying sky tone as the brush moves over the wet color. With a pointed, soft-hair brush, he draws the slender lines of the tree trunk with burnt sienna and ultramarine blue, then carries wiggly lines into the water for its reflection. After mixing cadmium red and cadmium yellow on the palette with a small bristle brush, he adds thick touches of this bright mixture to the edges of the tree on the left, the island below it, and the foliage in the central island to suggest warm sunlight on the dark shapes. Because of this special method of mixing color on the canvas, the final picture has a particularly lovely, delicate color harmony. The wet colors of Steps 2 and 3 flow through all the other colors that come afterward, creating the unified color scheme that's typical of this technique. If you study the individual brushstrokes, you'll see that they have a beautiful, soft quality because they're painted on a layer of wet color.

**Step 1.** For clarity of color, nothing equals painting with a knife. The polished, resilient, diamond-shaped blade of the painting knife deposits a smooth, dense stroke of color on the canvas—and that stroke always looks brighter and clearer than a brushstroke of the same color. After making a preliminary drawing on the canvas with ultramarine blue and turpentine, the artist knifes in the upper area of the sky with alizarin crimson, white, and a touch of ultramarine blue. He covers the lower sky with yellow ochre and white, warmed with a speck of alizarin crimson. With the knife, he scrapes the paint down to a very thin layer that will accept additional color.

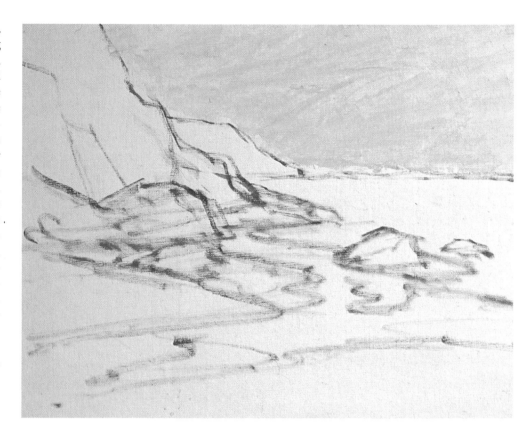

**Step 2.** The artist blocks in the dark cliff with strokes of ultramarine blue, burnt umber, yellow ochre, and white; the cool distant cliff with phthalocyanine blue, burnt umber, yellow ochre, and white; and the rocks' dark side planes with burnt sienna, ultramarine blue, and yellow ochre. The sunlit tops of the rocks are mixed with varying amounts of burnt sienna, yellow ochre, and white. The sand is yellow ochre, cadmium red, and white. The warm triangular shape on the sand at the left is burnt sienna and yellow ochre. The canvas is again scraped with a knife to force the color into the weave and expose its texture so the surface will grip additional strokes.

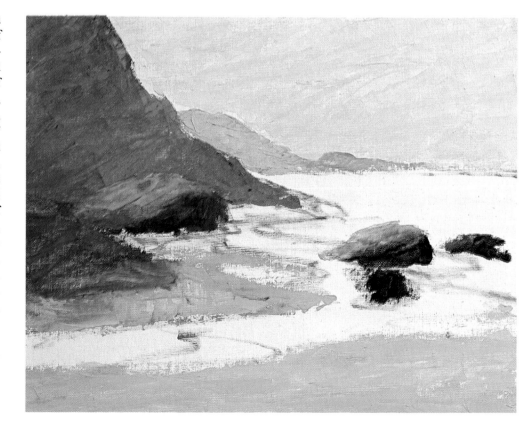

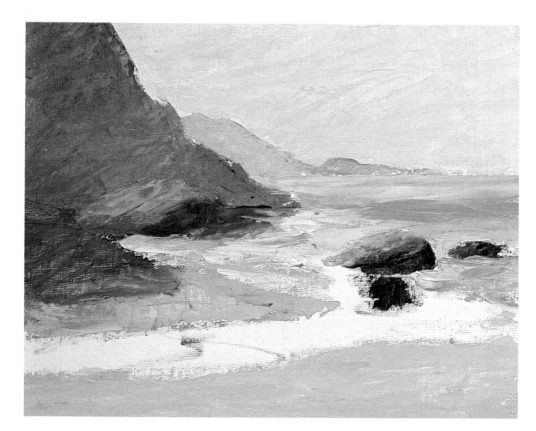

**Step 3.** Beneath the point of the dark cliff, a warm reflection is indicated with a few strokes of burnt sienna and yellow ochre. Then the water is laid in with long, horizontal strokes of phthalocyanine blue with some burnt umber, yellow ochre, and white. Obviously, more white is added to the paler strokes. At the edge of the horizon, just beneath the cool tone of the distant shore, the artist places a single, slender stroke of yellow ochre and white, warmed with a little alizarin crimson, to suggest the light of the sky shining on the surface of the water.

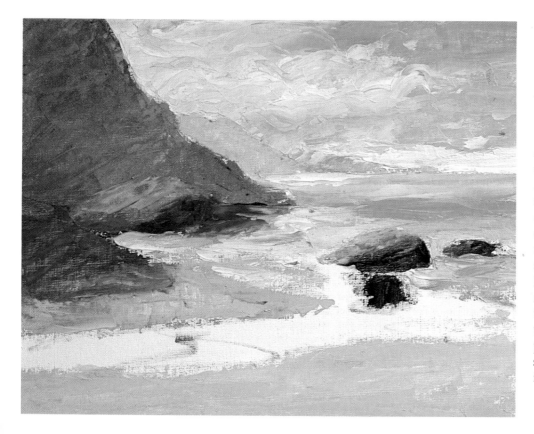

**Step 4.** On his palette, the artist blends several mixtures of phthalocyanine blue plus burnt umber and yellow ochre. He adds a little white for the cool patches of sky, more white for the pale tops of the clouds, and some yellow ochre for the warmer areas. Adding a touch of yellow ochre to enliven the white on his palette, the artist accentuates the sunlit tops of the clouds, and adds the strip of light just above the horizon. He varies the thickness of his strokes, sometimes applying the paint so thinly that the warm underpainting comes through, suggesting sunshine breaking through the clouds.

**Step 5.** The artist strengthens the shape of the distant cliff with the sky color and a little burnt sienna. He knifes a low cloud over the top of the cliff. Then he blends ultramarine blue, burnt sienna, yellow ochre, and a touch of alizarin crimson for the warmer strokes in the dark cliff; and ultramarine blue and burnt sienna for the darker strokes in the cliff and rocks. Strokes of sky color suggest reflections among the wet rocks at the base of the cliff. Just beneath the cliff, observe how a few vertical strokes of rock color and sky color are softly blended together with the knife to suggest the reflection of the cliff.

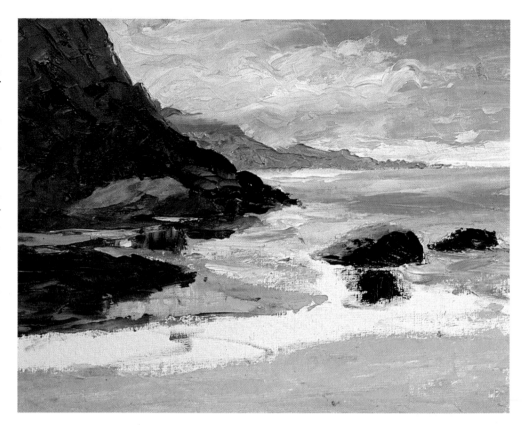

**Step 6.** The artist goes over the sand with thick strokes of yellow ochre, cadmium red, and white, plus a touch of cerulean blue. Then he blends a bit more blue into the foreground sand. He completes the water in the foreground with strokes of the various sky mixtures, accentuating the sparkling foam and the sunlight on the wet beach with thick strokes of white and yellow ochre. Picking up the dark rock mixture on his knife blade, he carries the reflection of the shadowy cliff down into the tide pool in the lower left. He uses thick strokes of the sand mixture to strengthen the sunlit tops of the rocks.

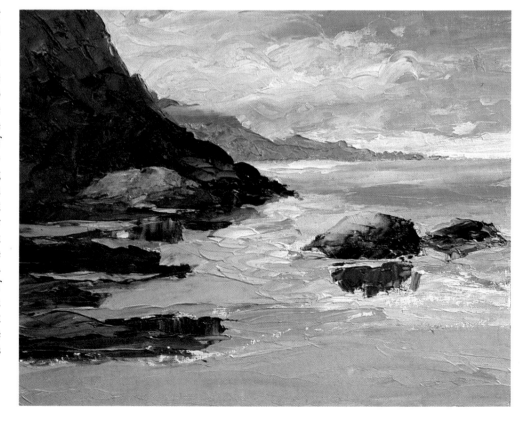

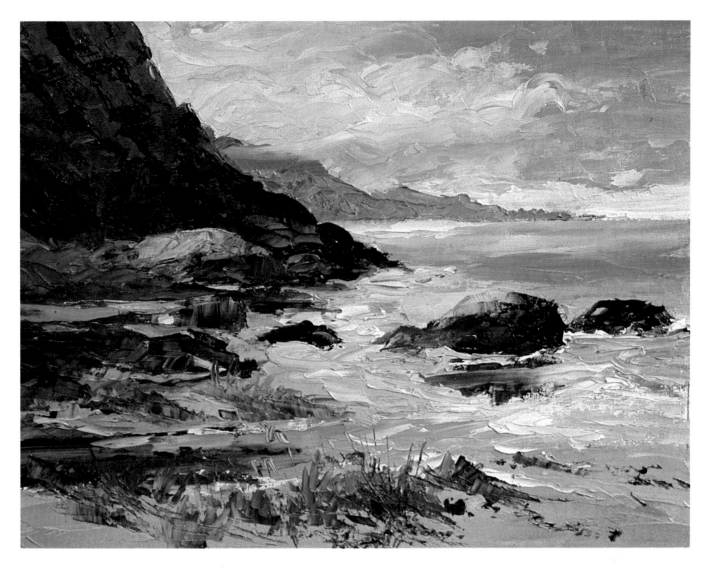

**Step 7.** Knife painting doesn't lend itself to intricate detail, but you *can* do more precise work than you might think. To strengthen the shadowy cracks in the dark cliff, the artist mixes phthalocyanine blue and burnt sienna. He adds the dark strokes by touching the side of the blade lightly against the canvas and then pulling the knife away. With this same mixture he adds more darks to the shore, including another rock at the edge of the beach. The artist also darkens the rock in the water at the extreme right. With the tip of the blade he adds quick, slender, curving strokes of sunlit foam (white tinted with yellow ochre) and he carries more sky reflections into the tide pool in the foreground. To suggest more movement in the foreground water around the rocks, he adds quick, choppy strokes of sky and cloud color. Finally, to indicate the scrubby grass on the sand, he uses the tip to paint short, irregular strokes of ultramarine blue, cadmium yellow, and a little burnt umber. These slender, linear strokes are again executed by pressing the sharp edge of the blade against the canvas and then pulling away. The finished painting looks delightfully rough and spontaneous, but the color has been carefully planned. The underpainting has *almost* disappeared beneath the heavy strokes of the overpainting, but not quite. You can still see the warm underpainting in the sky and in the shore. The color also has a freshness and purity that's unique to knife painting. To insure this purity, you must observe certain "rules" when you paint with a knife. Wipe the blade carefully and make sure that it's absolutely clean before you pick up a new color. Work with the absolute minimum number of strokes. Move your knife decisively across the canvas, and then pull the blade away without scraping back-and-forth—which will transform your bright color to mud. Mix your colors on the palette and be sure that the mixtures are right. Mixing colors on the canvas destroys their freshness. For knife painting, it's best to work on the woven texture of canvas, rather than on smooth, hard panels. If you really enjoy knife painting, you'll want to buy several painting knives with blades of different sizes and shapes.

**Warm and Cool.** If the strongest warm-cool contrast occurs at the center of interest—as it does in this mountainous landscape—the viewer's eye will go directly to that spot. The artist has planned this composition so that the center of interest is the group of sunlit rock formations surrounded by cool, shadowy cliffs on either side.

**Bright and Subdued.** Planning your contrasts of bright and subdued color is another way of directing your viewer's attention. The viewer's eye zigzags across the shadowy landscape, following the brightly lit water to the dark horizon and stopping at the patch of sunny sky. The artist reserves his most brilliant color for the sky just above the dark horizon.

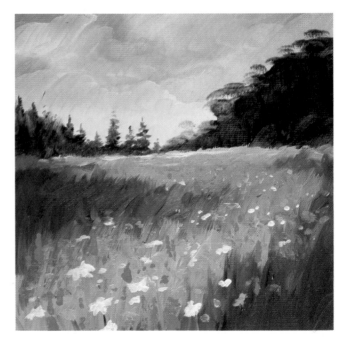

**Light Against Dark.** Still another dramatic compositional device is the contrast of light against dark—the contrast of value. To focus your attention on the top of the rock, the artist places his lightest value right there, surrounding it with darkness. The artist has thrown a spotlight on the center of interest.

**Leading the Eye.** Color can provide a path for the eye. Here, the bright flowers carry you into the picture from the lower left, and then swing you gently around to the center of the picture, where the focal point is the break in the foliage at the horizon. The colorful path is accentuated by the dark patches in the meadow surrounding the flowers.

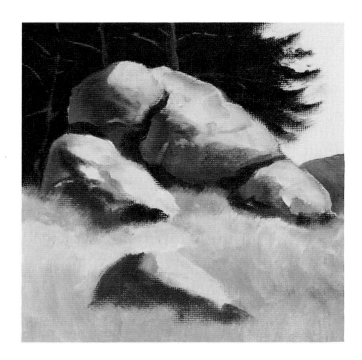

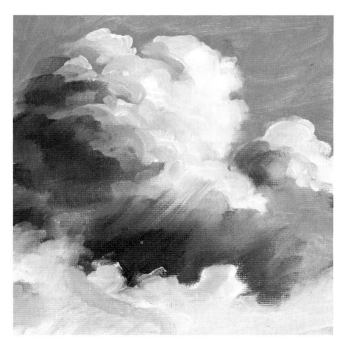

**Cubical Form.** To understand color, you must understand light and shade. Sunlight strikes these rocks as it would a cube. The top planes receive direct sun, while the side planes are in shadow. Where the light and shadow meet, there's a silvery halftone. And at the left side of each shadow, there's a hint of reflected light.

**Rounded Form.** Light from the sun curves around the puffy clouds very much as it would on a sphere. From right to left, you see the same four tones that you saw on the rocks: light, halftone, shadow, and reflected light. The reflected light bounces into the shadow from the sun on a nearby cloud.

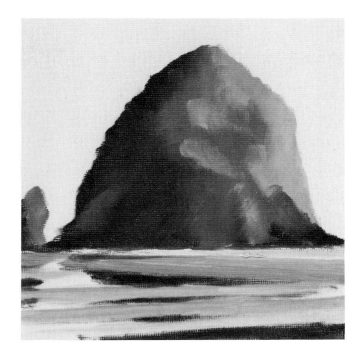

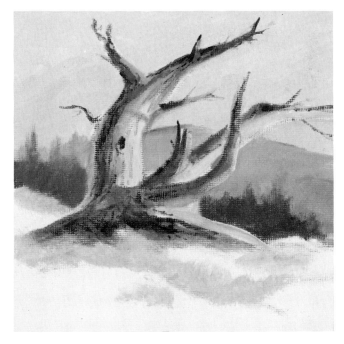

**Conical Form.** This tall rock formation on a beach isn't exactly conical, but the light moves over the form as if it's a cone. Looking from right to left, you again see light, halftone, shadow, and just a bit of reflected light within the shadow, picked up from the mirror-like surface of the water.

**Irregular Form.** Not every form is geometric, of course, but once you've learned to recognize those four degrees of light and shade, you can see them on almost everything. Here, for example, on the twisted shapes of the dead tree, you can still see the same gradation—light, halftone, shadow, and reflected light—bouncing off the shining surface of the sunlit snow.

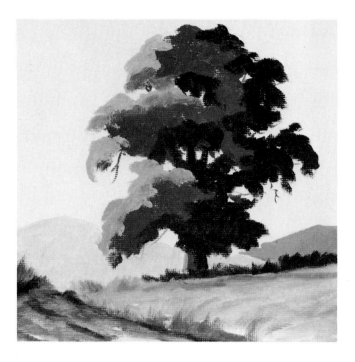

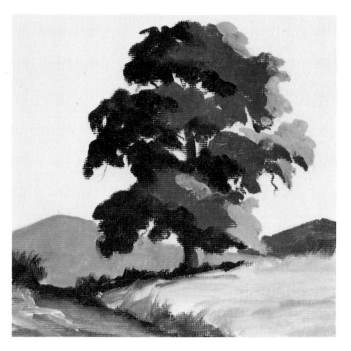

**Side Lighting from Left.** The direction of the light has a powerful influence on form and color. This tree receives the sunlight from the left. Thus, as you look from left to right, you see distinct zones of light, halftone, and shadow. In this case, there's no reflected light, but since the light comes from the left, the tree casts a shadow on the ground to the right.

**Side Lighting from Right.** The sequence of light, halftone, and shadow is reversed when the same tree receives the sunlight from the right. Once again, you see the three degrees of light and shadow, but in the opposite order. And because the light comes from the right, the cast shadow falls on the ground to the left of the tree.

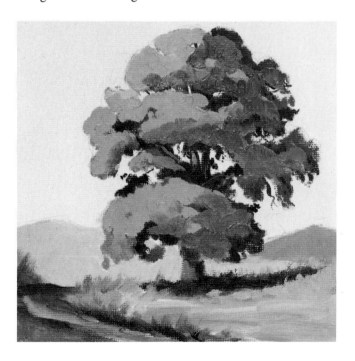

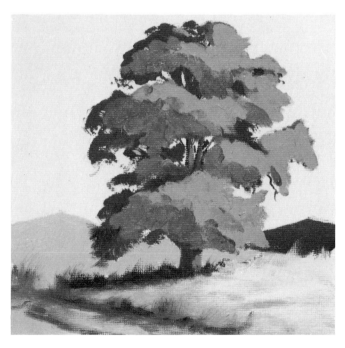

**Three-Quarter Lighting from Left.** Again the light comes from the left, but now it's moving over your left shoulder and striking the tree at an angle, rather than coming directly from the side. Thus, there's more light on the tree, somewhat less halftone, and just a bit of shadow at the extreme right. The cast shadow is at the right and slightly behind the tree.

**Three-Quarter Lighting from Right.** When the light comes diagonally over your right shoulder, the sequence of tones is reversed again and the cast shadow moves to the left. In both these examples of three-quarter light, notice that the sun is slightly above the tree, so the halftones and shadows tend to move under the leafy masses.

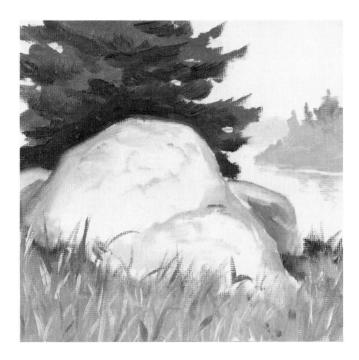

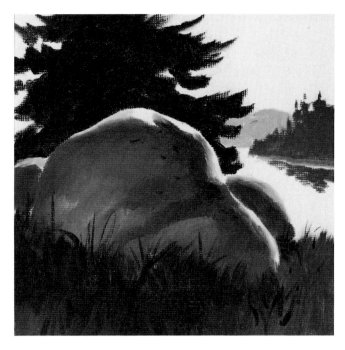

**Front Lighting.** When the sun is above and behind you, the light strikes the center of the form, and the halftones occur around the edges—as you see in this rock formation. Most of the rock is in bright sunlight, with so little darkness that there really are no true shadows, and the halftones create continuous strips of soft tone around the shapes.

**Back Lighting.** When the sun is behind the rock, the effect is exactly the opposite of front lighting. The face of the rock is almost entirely in shadow, with just a slender rim of light around the edge. However, there are strong reflected lights within the shadows, possibly bouncing off another rock or a pool of water that you can't see in the painting.

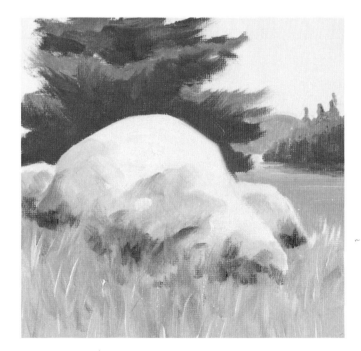

**Top Lighting.** At midday, the sun is directly overhead. The tops of the forms receive the strongest light, while the bottoms are in shadow, with the halftones somewhere in between. It's usually hard to see the reflected light within the shadow—and there may not be any.

**Diffused Light.** On an overcast, foggy, or hazy day, you may not see the usual gradation of light, halftone, shadow, and reflected light. You simply have to study your subject carefully and paint the pattern of light and shadow that you actually see. In this case, the rock contains a patch of soft light—perhaps from a break in the clouds—surrounded by soft shadow.

**Sunny Day.** Changes in the weather can completely transform the pattern of light and shade on your subject. On a sunny day, there are strong contrasts in this coastal landscape. You can see each tone very clearly: there are crisp lights and clearly defined shadows. Cast shadows, like the one to the left of the big rock at the center of the beach, may turn out to be surprisingly pale because they pick up reflected light from the sky or from nearby reflecting surfaces like the sunny sand or water. On the sunlit cliff in the upper half of the picture, it's easy to see distinct planes of light, halftone, and shadow, with hints of reflected light within the shadows.

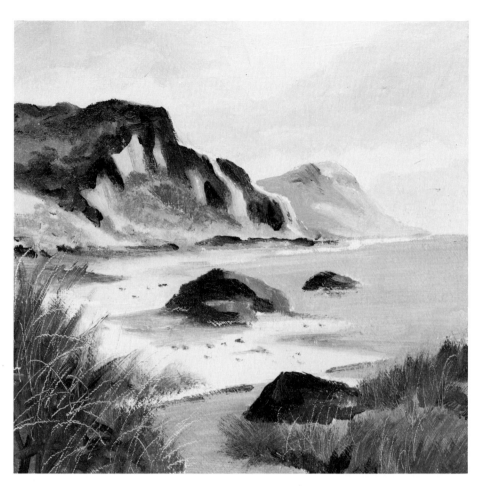

**Cloudy Day.** All the forms tend to become darker on a cloudy day, but you can still see the various degrees of light and shade if you look carefully. Surprisingly, a cloudy day can produce dramatic lighting effects if there are breaks between the clouds, allowing the sun to shine through and spotlight certain parts of the picture. That's what happens here, when the clouds open to allow a ray of light to illuminate the beach. At that one spot in the landscape, there are bold contrasts of light and shade, similar to those on a sunny day. In the foreground and on the cliffs, the clouds cast large, dark shadows. You can often create a powerful composition by placing cloud shadows on some parts of your picture, and spotlighting other areas.

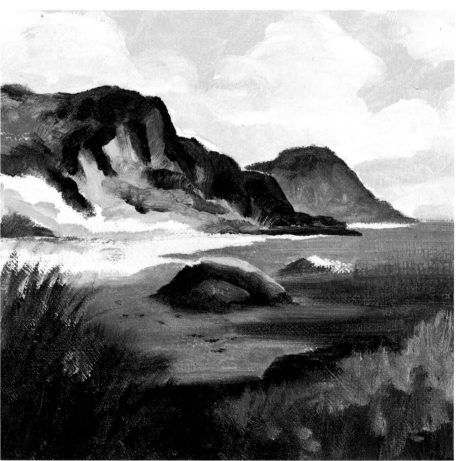

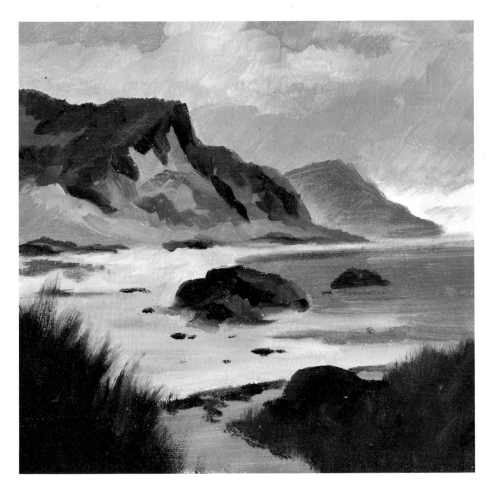

**Overcast Day.** When the light of the sky is screened by a layer of clouds, only a limited amount of light comes through, and all the values in the landscape move lower on the value scale. There are no really strong contrasts of light and dark, since the lights are all fairly dim. Sometimes there's a small break in the clouds, as you see along the horizon at the right. Such a break may allow a bit more light to fall on some particular part of the landscape, as it does here on the beach. But the total effect is still quite somber. This doesn't mean that an overcast day is a bad subject for a painting; on the contrary, many artists enjoy capturing this somber mood.

**Hazy Day.** At times, the entire landscape is covered with a haze that seems to drop a delicate veil over all your colors. Unlike overcast weather, when value differences may still be visible, haze makes it virtually impossible to see the distinction between light, halftone, shadow, and reflected light. The magic of a hazy day is that the weather reduces almost all the shapes to simple, mysterious silhouettes. To capture this magic, you must observe all the values carefully and match them accurately when you mix your colors.

**High Key.** As you study the values of your subject, it's often helpful to decide on the *key* of your picture. In a high-key picture like this one, *all* the values—including the darks—are fairly light. Nearly all your tones come from the upper part of the value scale. This means that the darkest tones of the picture are middle values, while everything else is lighter still. In this hazy winter landscape, with the snow falling, the darkest shapes are the evergreens, but see how pale they look in comparison with the two other studies of the same subject on this page.

**Middle Key.** When the snow stops falling and the sun begins to come out through the haze, this winter landscape is transformed to a middle key. That is, most of the values come from the middle area of the value scale. The dark trees are slightly darker, but they're still not as dark as they'd be if the picture were in a low key. The stream grows darker and so do the shadows on the mountain. The snow is a little darker too, although you can still see some fairly bright patches of sunlight that come from the upper end of the scale.

**Low Key.** When most of the tones in a landscape come from the lower part of the value scale, the picture is in a low key. The darks, like the evergreens and the stream, are apt to come from the very end of the value scale. The shadows on the snow and on the mountain come from slightly higher places on the value scale, while the sky and the lighted areas of the snow come from the middle area of the scale. In this low-key picture, the shadows on the snow are roughly the same value as the evergreens in the high-key picture. The best way to learn about high, middle, and low key is to go outdoors and paint some small oil sketches with mixtures of black and white tube color.

**High Contrast.** It's also important to decide whether you're painting a high-, medium-, or low-contrast subject. Examine the values you see on your subject. If the values are drawn from all parts of the value scale, you'll probably be painting a high-contrast picture. In this landscape in bright sunlight, the darkest notes among the trees and shore come from the lowest area of the value scale, the sunlit clouds and water come from the upper part of the scale, and the middletones come from places on the scale between the two extremes. A high-contrast subject has no particular key because the values come from the full range of the scale.

**Medium Contrast.** On a day that's partly cloudy or slightly overcast, with some sun breaking through, the same landscape is likely to become a medium-contrast subject. Now the darks turn somewhat lighter and the lights turn somewhat darker. But there's still a reasonable contrast between the lights (the sky and water) and the darker tones of the trees and shoreline. Only a few tones come from the far ends of the value scale—most of them come from the center of the value scale. This medium-contrast landscape is also in a middle key. But medium contrast and middle key don't always go together. The low-key landscape on the opposite page is also in the medium-contrast range.

**Low Contrast.** On a hazy day, this landscape is transformed into a low-contrast subject. The lights grow darker and the darks grow lighter, so there's less contrast between them. Compare this with the high-contrast oil sketch, where the darks are deeper and the lights more intense. This hazy landscape is in a fairly high key, since most of the tones come from the upper part of the value scale. But, again, low contrast doesn't necessarily mean high key. As night falls, this landscape would still be in the low-contrast range, but it would fall into a low key. Make some more black-and-white oil sketches to explore these tonal contrasts.

**Step 1.** Here the artist shows how he paints a high-key landscape. Whether in black-and-white or in color, the technique is the same. After the usual brush drawing of the main shapes in the composition, the artist begins by blocking in the lightest and the darkest values in the painting. After indicating the rough shape of the dark foliage at the top of the rocks, and the palest tones in the sky, he then has a fairly accurate idea of the tonal range of the entire picture. In other words, he knows that nothing will be darker than the dense mass of foliage or lighter than the palest tone in the sky.

**Step 2.** The artist blocks in the dark shapes of the clouds with a value that's approximately midway between the palest tone in the sky and the dark tone of the foliage. He carries this middletone down over the landscape on either side of the sunlit rock formation. Then he paints the sunlit rocks in a flat tone that's approximately the same value as the pale tones in the sky. Thus by the end of Step 2, the artist has established the dark and light extremes of his painting, as well as an important middletone that falls somewhere in between.

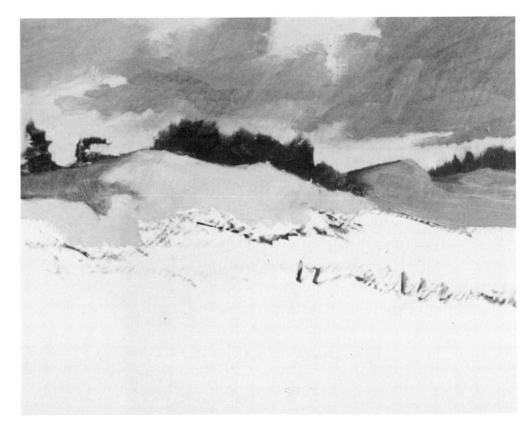

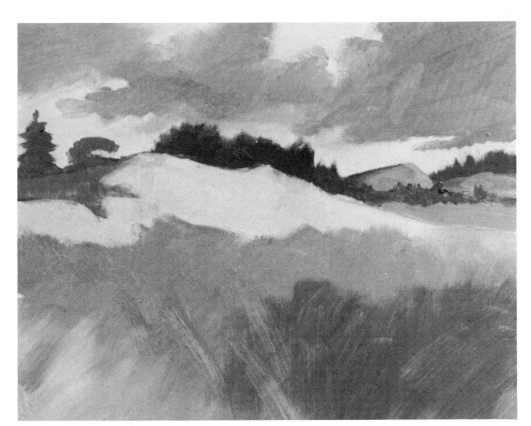

**Step 3.** Working now on the foreground, the artist covers the shadowy meadow with a middletone like that of the sky. In the lower right, he adds a second, darker middletone. He then adjusts the tree shapes at either end of the horizon, and darkens the land below the left-hand trees. Now he has a classic four-value landscape: dark, light, and two middletones.

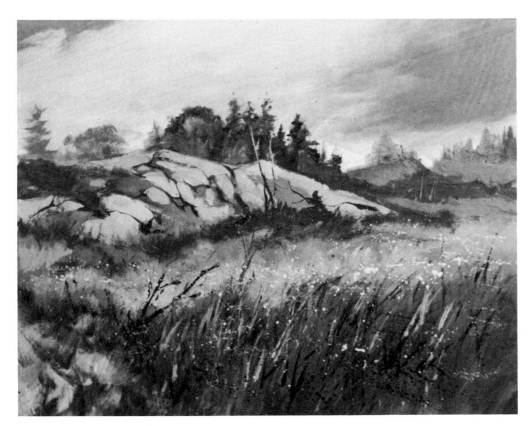

**Step 4.** The artist adjusts the tones and adds details. He makes one really important change: he paints out most of the middletone of the sky to re-establish the original light value, forming a pale setting for the dark trees. He adds the details on top of the dark trees in lighter values. The original dark tones showing through give depth and weight to the grouping. The shadows within the rocks are painted in middletones, while the cracks are painted with the same dark tone used in the trees. The artist completes the meadow by brushing in grasses and weeds with strokes of the lightest and darkest tones of the picture.

**Step 1.** The artist doesn't hesitate to execute the preliminary line drawing with dark brushstrokes, since the picture will be generally dark. He then blocks in the dark middletone of the distant mountain and the lighter middletone of the sky and water. He also paints the moon, which will be the lightest note in the picture. Thus, by the end of Step 1, he's established *almost* his full value range: the light and two middletones.

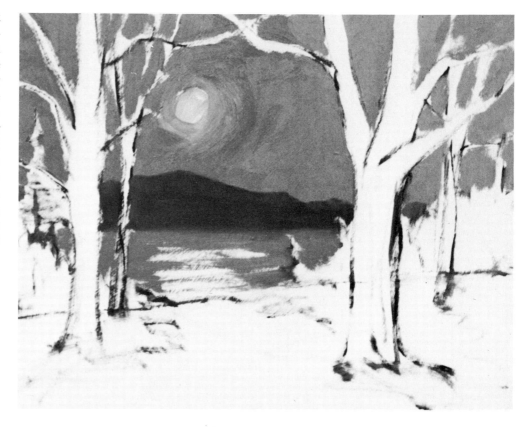

**Step 2.** At the edge of the lake, the artist paints the silhouettes of the evergreens with his darkest value. In the foreground, beneath the big trees, he repeats the two middletones that appear in the sky. The dark middletone is directly beneath the trees and the lighter middletone is on the curving road lit by the moonlight. Thus, by the end of Step 2, the artist has established the full value range of the painting, even though he hasn't completed the big trees and the moonlit water that are so important.

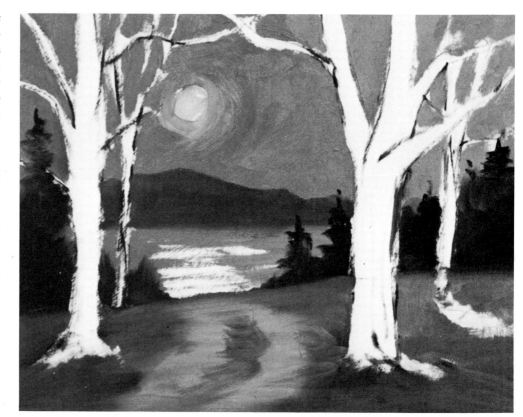

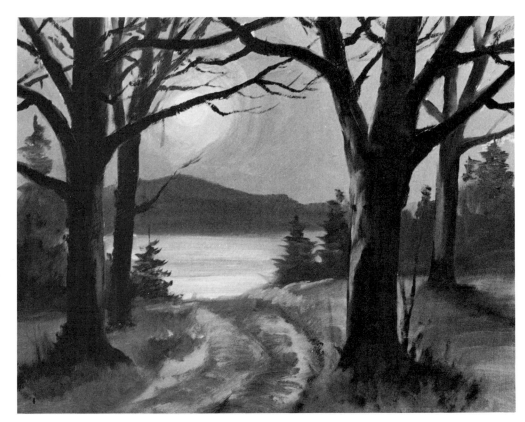

**Step 3.** The artist paints the trunks and branches, as well as a suggestion of shadow at their bases, with his darkest value. On the moonlit edges of the trunks, he places the lighter middletone. The water is lightened because it reflects the bright, pale moonlight, and the sky is lightened as well. The artist decides momentarily to lighten the evergreens along the shore so that they'll contrast with the dark trunks in the foreground. Now these evergreens are the same dark middletone as the mountains. The artist continues to develop the foreground with the two middletones: one light, one dark.

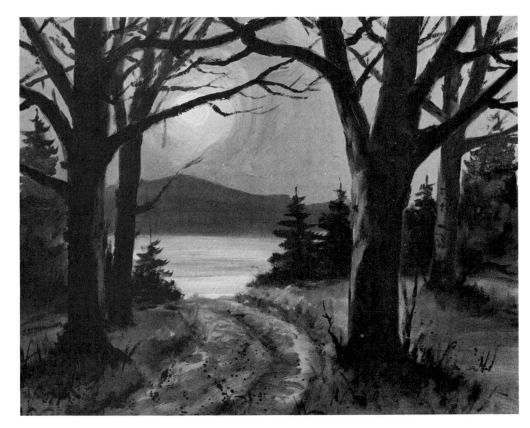

**Step 4.** The artist darkens the evergreens again to strengthen their contrast with the mountain. Working with the darkest tone, he adds more branches to the trees, textural detail to the trunks, and shadowy grasses on the ground. The finished painting is *essentially* low-key because the dominant tones are the darks of the tree trunks and evergreens, plus the dark middletones of the mountain and ground. But a low-key picture *can* have some bright areas to accentuate the darkness—such as the paler tones of the moon and water, and the lighter middletones of the sky and parts of the ground. Don't be surprised if a low-key picture is sometimes in the high-contrast range.

**Step 1.** It's important to maintain a clear idea of the placement of the light in a high-contrast picture. So the artist draws the shapes carefully with his preliminary brush lines, and then he blocks in the pale middletone of the sky, surrounding the dramatic rock formations on which the bright sunlight will fall. At the base of the mountains, he also indicates the placement of the light middletone on the tops of the trees.

**Step 2.** The shadow sides of the looming, rocky shapes are actually a very dark middletone, falling just above the lowest end of the value scale. The artist blocks these in with decisive strokes. He then repeats this dark middletone along the shadowy undersides of the leafy masses of the trees along the shore. Even at this early stage, the canvas contains three of the four major values: the light on the mountains, represented by bare canvas at this stage; the pale middletone that appears in the sky and at the tops of the trees; and the dark middletone that appears beneath the trees and on the mountains. Only the dark is missing.

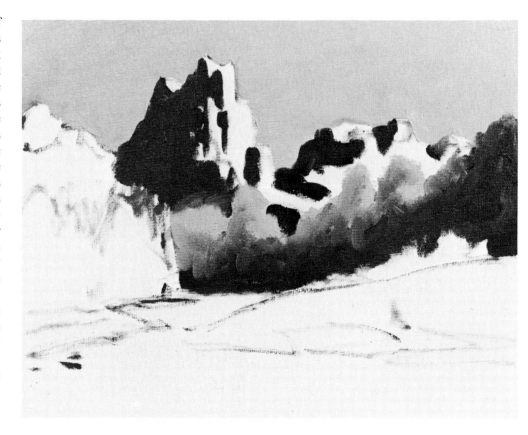

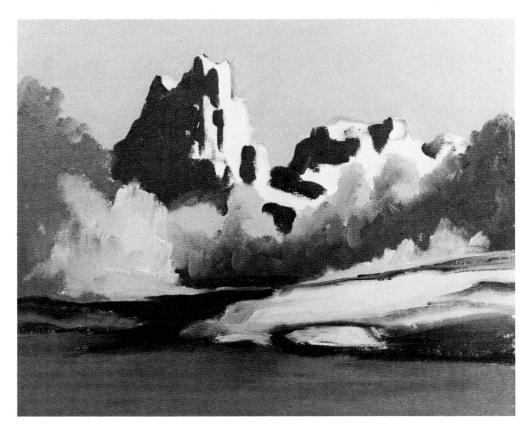

**Step 3.** The water in the lower third of the picture is now covered with a value that comes fairly close to the dark middletone that first appears in Step 2. Then the artist introduces the darkest notes in the picture—the deep shadows along the shoreline. He starts to add the lights: the blurred shape of the tree on the shoreline at the left; the low, sunlit trees on the shoreline at the right; and the sunlit tops of the low rocks in the water at the right. For the trees at the extreme left, he introduces a *third* middletone that's distinctly lighter than the dark middletone on the rocks.

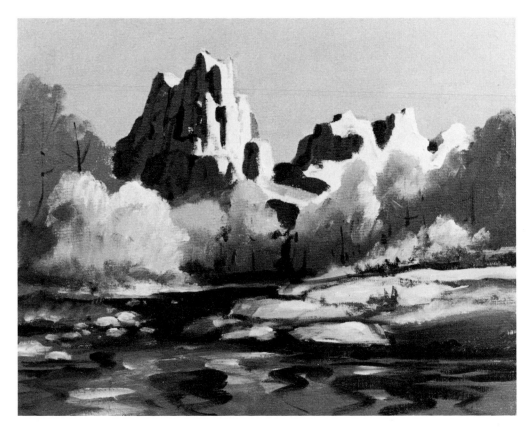

**Step 4.** Within the dark middletones on the sides of the big rock formations, the artist indicates the details of the rocks with the dark tone he's used in the water. He repeats this dark tone in the wiggly reflections in the pond and in the tree trunks along the shoreline. More detail is added to the water and to the low rocks with strokes of the middletones. As he develops the tones of the trees, you can see patches of light and two middletones among the shapes. This high-contrast picture demands a diverse range of values, so the artist has decided on five values rather than four: dark, light, and *three* middletones.

**Step 1.** As you've seen, the usual strategy in painting most pictures is to establish its tonal range as early as possible by blocking in the major values. You can paint them in any order—there are no rigid "rules." Working again with four values, the artist places the lightest value (which is actually rather dark) in the sky. He paints the clouds with the lighter middletone. Then he paints the trunk and branches of the tree with the darker middletone, and with the darkest tone—which appears at the base of the tree. Only half the canvas is now covered with wet color, but the four major values are already there.

**Step 2.** Moving to the landscape beyond the tree, the artist paints the irregular bands of distant trees with the dark value and a middletone that's roughly comparable to the middletone in the sky. Between the rows of the distant trees, he indicates the snow with the light value that also appears in the sky. At this early stage, it's still difficult to decide what's sky and what's land, but that will become clearer in the next step.

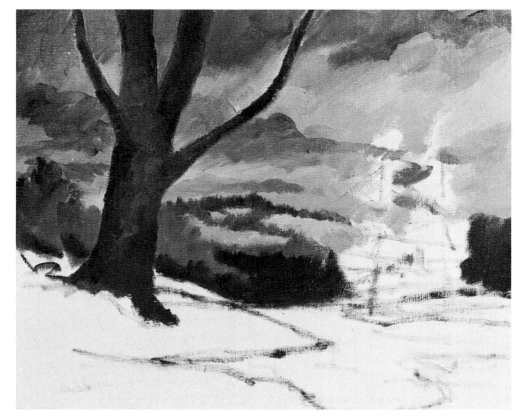

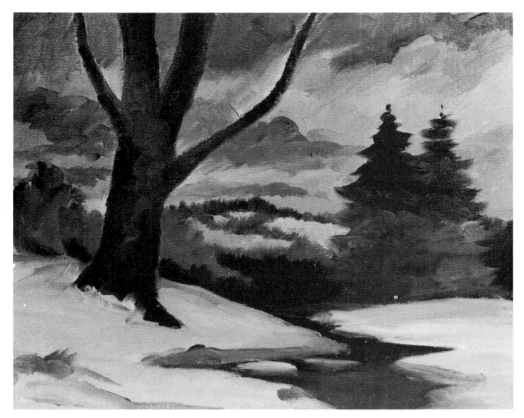

**Step 3.** In the foreground, the artist blocks in the lightest areas of the snow with the pale value that he used in the sky. He adds the strips of shadow on the snow with the lighter of the two middletones. The frozen stream is painted with two values: the darkest value and the dark middletone. Within the two evergreens at the right, you can see the two middletones and the dark. Now you can see that the sky ends at the dark strip of horizon halfway down the picture.

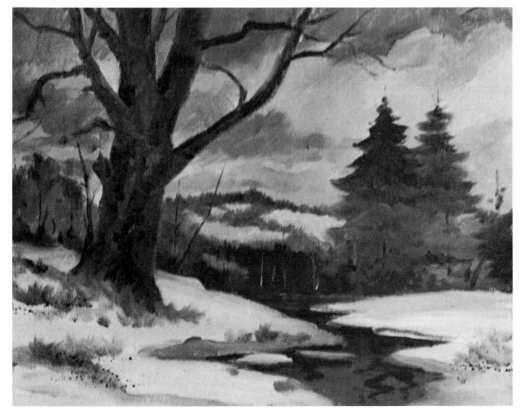

**Step 4.** In the final stage, the artist refines the values and adds details. He continues to develop the big tree at the left by adding touches of the two middletones, plus a few more darks. He adds trunks and branches to the distant trees. Irregular, dark strokes indicate reflections in the frozen stream. With touches of the lighter middletone, he adds frozen weeds and other debris to the snow in the foreground. In the finished picture, the four values flow softly into one another.. Most of the values come from the middle and lower parts of the value scale—and this is obviously a low-contrast picture.

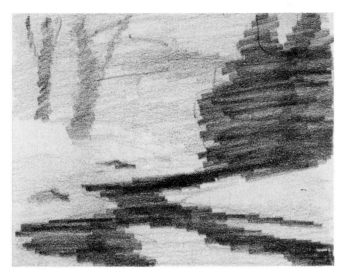

**Sketch for Demonstration 1.** Because values are so important to the success of any painting, many artists do little value sketches in pencil or chalk before they begin a picture. In this way, they visualize the distribution of values to plan their composition and their color mixing. Here's the artist's value sketch for Demonstration 1—done in a couple of minutes with quick, scribbly pencil strokes. It's obvious that the strongest darks are in the foreground; the lightest areas are in the sky and water; while the two middletones are in the distant shore, the evergreens, and their reflection.

**Sketch for Demonstration 3.** In this value study for Demonstration 3, the artist records the dark values of the evergreens at the right and the zigzag pattern of the dark stream in the foreground. The lights are in the snow, while the middletones are in the upper half of the picture. In the demonstration painting, the artist has made certain changes, such as darkening the trees at the left. There's nothing sacred about a value sketch—you can always change your mind later. But it's useful to begin with such a sketch even if you improve upon it in the finished painting.

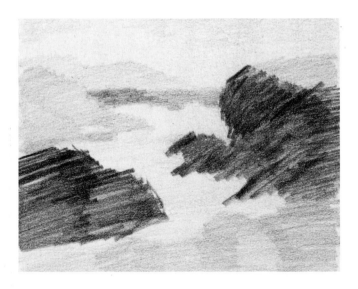

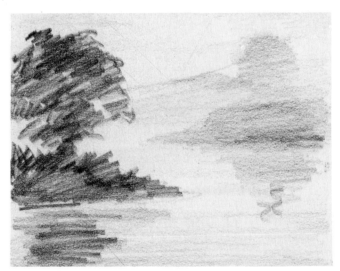

**Sketch for Demonstration 4.** The value sketch places the strongest darks on the shadowy rocks in the foreground; the palest lights in the sky and in the foamy water between the rocks; and the middletones in the immediate foreground, and in the rocks and sea in the middleground. But in the finished painting, the artist has changed his mind, darkening some of the rocks that appear as light middletones in the sketch. If you decide to alter your values midway through the painting, it's often helpful to make a few more value sketches to test out other possibilities.

**Sketch for Demonstration 9.** Although a wet-into-wet painting *looks* as if it happens by accident, such spontaneity is the result of careful planning. The value sketch shows a simple but effective strategy. Almost the entire canvas is a very pale tone from the upper part of the value scale. Just the dark tree and a bit of shore at the left represent a dark note from the lower end of the scale. The only middletones are the distant mountain and the wooded island at the center. The bold design is captured in the value sketch, although it looks like a mere doodle.